D0116137

Tom Lynch's Watercolor Secrets

A master painter reveals his
strategies for success

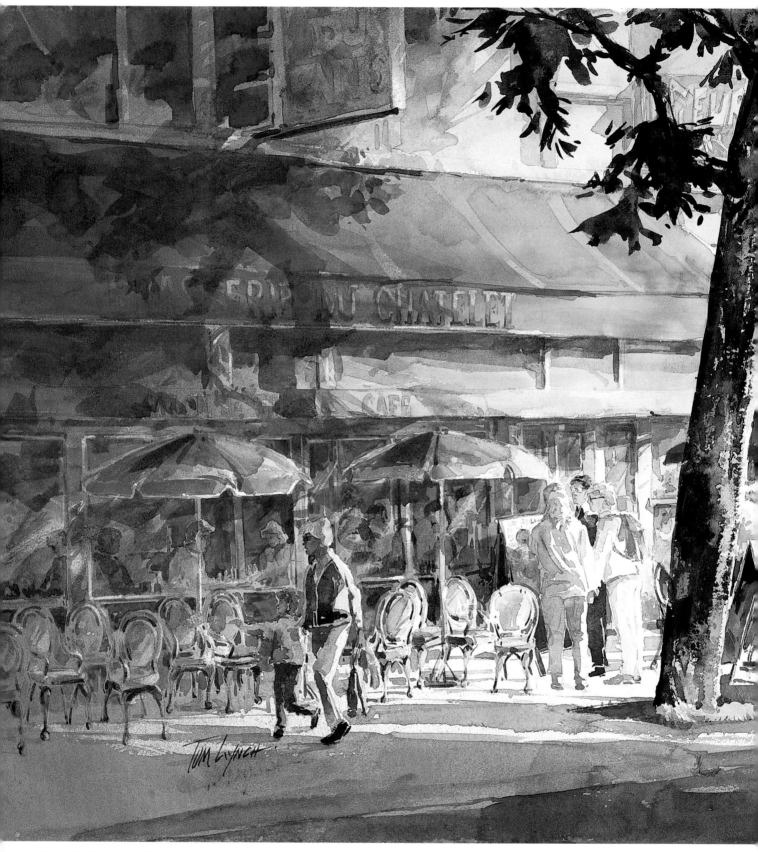

"Café Shadows" (22 x 30")

Tom Lynch's Watercolor Secrets

A master painter reveals his strategies for success

by Tom Lynch

international
artist

Dedication

It's time for all the world to know that I secretly hide my wife's name, Linda, in all of my paintings! While I'm grateful for my life as an artist and all that it has brought me, I'm even more grateful for a wonderful wife. I dedicate all my artistic efforts and this book to you, the love of my life . . . **Linda**.

International Artist Publishing, Inc
2775 Old Highway 40
P.O. Box 1450
Verdi, Nevada 89439

Edited by Jennifer King
Managing Editor Terri Dodd
Design by Vincent Miller
Photography and illustrations by Tom Lynch
Typeset by Cara Miller and Ilse Holloway

Printed in Hong Kong

04 03 02 01 00 5432

Library of Congress Cataloging-in-Publication Data

Lynch, Tom.
 [Watercolor secrets]
 Tom Lynch's watercolor secrets : a master painter reveals his six strategies for success / by Tom Lynch.
 p.cm.
 ISBN 1-929834-01-2 (hc)
 1. Watercolor painting–Technique. 1 Title.

ND2430.L96 2000
 751. 42'2 – dc 21 00-025680

Acknowledgments

There are a number of other people to whom I'd like to extend my thanks and gratitude . . .

To our children. I'm often asked what my finest accomplishment is, and the answer is easy . . . our children! We have four great young adults that I thank for their love and support, and for the joy they've brought into our lives — Alysha (and her husband Russ), Tami, Traci and Michael (and his wife Liz). And now two grandchildren, Cassandra and Dayne Thomas!

To my parents. I've been blessed with great parents, and I'm very thankful to you. You have spent your lives thinking of your children first. When anyone says what a nice guy I am, I proudly tell them that's the way I was raised.

And I hope my efforts will continue to be a reflection of you both.

To my sisters, Sharon, Pat and Lisa. A few miles and a couple of careers keep us apart, but that will never diminish the love and pride I have in you.

To my best friends, Matthew, Joe and Denny. I never had any brothers, but if I could pick some, you'd be my choices. You have brought friendship, balance and a fresh perspective to all I do. Thank you. Let's tee it up.

To my teachers. When any student compliments me on how great the class was, I can only say that I've been guided and influenced by the best — Bill Florence, John Friedrickson, Bob Doherty, Jack Leese, Vern Stake, Irv Shapiro, John Pike, Ed Whitney, Robert E. Wood and Nita Engle.

To my students. The joy of watching someone learn will always be with me. Your desire to learn has kept alive my desire to teach. A special thanks to a few who have chosen me as their mentor and will take my teaching to a new level — Ana Quiros, Tom Jones and "the Lynch mob".

To my staff leader and friend Joyce Hycner. You manage me, my schedule and 10,000 other details wonderfully. Thank you. To Paul and Sylvia. Thanks for sending me. All is well now.

And to my publisher, Vincent Miller, and editor Jennifer King. Thank you for your patience and professional assistance in helping an artist sound like a writer.

"Venice Highlights" (22 x 30")

Contents

Getting the most out of this book

Each strategy has its own easy-to-find color-coded section.

Every chapter is broken down into helpful sections that give you in-depth understanding of how to apply each strategy to your own work.

Presenting the strategy with a studio painting

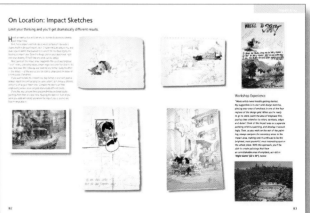

Using the strategy on location

Page 60

Shapes

Create a better designed painting using interesting, non-static, extraordinary shapes

- Understand design shapes.
- Learn ways to alter shapes.
- Practice on location shape sketches.
- Change shapes to salvage a static design.
- See how Tom uses interesting shape design in a gallery of his paintings.

Page 74

Impact Area

Create the area that showcases your painting

- Learn to define your impact area.
- Use Tom's special grid designed to place an "area of emphasis".
- Practice on location impact areas sketches and exercises to help you define the impact area.
- Learn how the brightest colors and sharpest edges lie within the impact area.
- See before and after paintings with and without impact areas.
- Recognize the impact area in a gallery of Tom's paintings.

Page 88

Expression & Mood

Let your feelings control the direction of your painting

- Learn to use descriptive words to set up a mood for your paintings.
- Practice 3 different styles of mood for the same scene.
- Learn to paint what you feel, not what you see.
- Learn how a "mood feeling" can salvage a painting.
- Understanding mood vs. fundamentals.
- See how mood created Tom's exceptional gallery paintings.

Page 102

Demonstrations and Gallery

A collection showing all the strategies combined

See how Tom involves all the strategies in 4 full-scale demonstrations, each supported by a gallery of his own work.

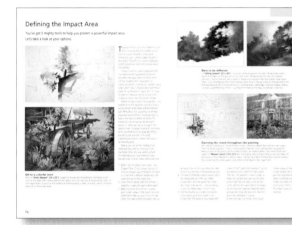

Understanding the strategy

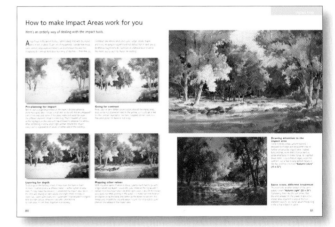

Demonstrating the strategy

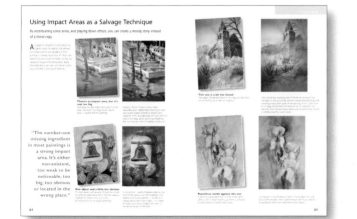

Using the strategy as a salvage technique

Showcasing the strategy

7

Introduction

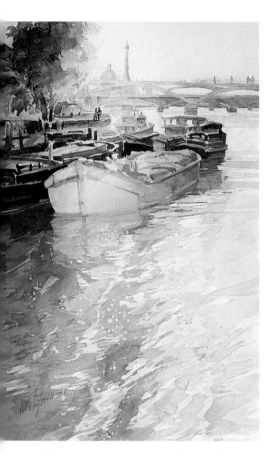

**"Reflections on the Seine"
(22 x 15")**

Artists have the ability to see things in nature that others don't. I know that when I look at the world, the artist within me sees things that evoke an emotional response. This response is the seed of inspiration, motivating me to share my passion in art. Perhaps that's why I'm never satisfied with reporting the plain, ordinary, factual things that everyone else can see. I'd much rather take my uniquely personal vision of the world and express it in my paintings.

While there are many possible ways to share a personal view of the world, the key to expressing my view is exaggeration. If there's a suggestion of light, I give my painting a blast of light. If my subject has a little color, I put in dazzling color. As I approach each new work, I think about how I can play up shapes, push values and enhance the impact area — whatever deliberate choices I can make to express the unique way I see things. When I make something special out of something ordinary, I get an adrenaline rush that tells me I'm creating art, not just painting pictures.

Affecting viewers with your style

The best part about creating expressive paintings is the way they affect people who view them. But to understand my philosophy on how art influences people, we have to start with the different stylistic categories of art, which I think of as a scale:

In my experience, the closer the art is toward the realistic end of the spectrum, the more viewers will start a thought process that leads them to analyze and identify. They will play a mental game of "Name that object" or "Name that place". If the banana looks real enough, they may even search for the Chiquita label. Then they'll say, "That looks just like a photograph". Ugghh! That's the kiss of death for a painting. Once the subject has been identified — which only takes a moment — there's nothing left for them to do and they move on to something else.

The truth is, most people are bombarded with facts all day long, so they're looking for a doorway into something extraordinary and unexpected. Art that moves toward the impressionistic or abstract parts of the range offers viewers just such an escape from the "real," everyday world of facts and things. These types of art present a different world they know nothing about, but want to discover and explore.

Once you've hooked them and drawn them in, imagination takes over. Viewers will readily place themselves in your picture so they can enjoy the sensations they find there. They'll now embrace the tree as "vibrant", the house as "bright", the banana as "fresh". Your art may even trigger a memory, making that person feel really good about themselves. And, if every inch of the painting is filled with a variety of colors, shapes, patterns, edges, textures or values — as it should be — viewers won't want to leave the painting because something different is happening every two inches. They'll sit and look at that kind of painting for hours, probably making the comment, "Wow, what a vision of the world around us!"

So have I convinced you to move toward the right on that scale? Realism may be more technically "correct", but as you move into the range of impressionism, paintings become a lot more interesting. Don't worry about people not understanding your "looser" or "painterly" efforts. If they're entertained, they'll discard their preconceived expectations and be comfortable with the idea that this isn't trying to be "real". They'll see your art as a suggestion, an impression, and they'll enjoy it for the fresh perspective and escape it offers.

I admit, not every viewer will respond this way. I know for a fact that rose enthusiasts from the Society of Rose Growers or the Royal

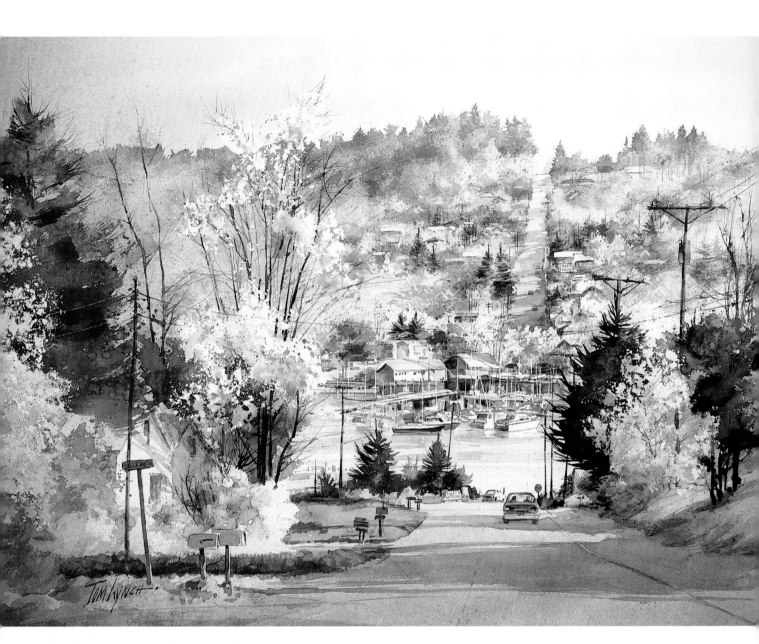

"Gig Harbor" (22 x 30")

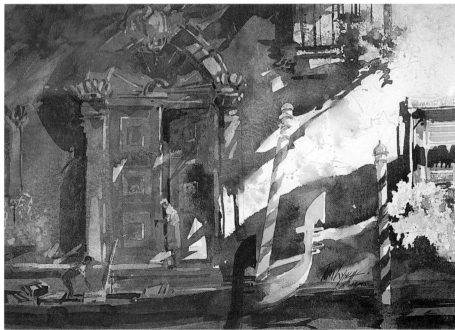

"Venice Shadows" (15 x 22")

9

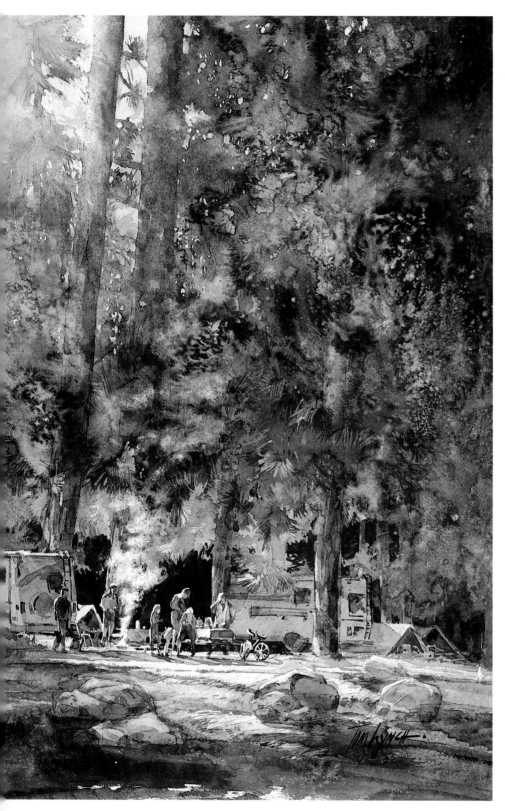

"Yosemite Campers" (22 x 15")

Botanical Garden will never ask me to illustrate the cover of their next book or convention program because they want to see a particular kind of rose they can identify. But I'm convinced that the other seven billion people in the world will enjoy my artistic renditions of flowers, even if they're only rose-like, even if they don't really exist, as long as they're interesting!

Embracing change

Believe me, you can learn to create the kind of expressive, exciting, entertaining paintings I'm talking about. Many times someone will say to me, "Oh, you have such a gift", but I quickly disagree with them. I have acquired all that I can do because of what I've learned, either through teachers or my own experimentation. The only thing that comes to me naturally is desire. If you've got this same desire, you can take your artistic skills to a new level.

Just remember, if you long to be a better painter, you're going to have to embrace change — I'm talking about change in a big way. Challenge yourself to achieve a dramatic new way of painting that generates some exciting superlatives. Be willing to create some works of art that will make your family say, "Wow! Is that yours?" instead of, "Oh, that's nice. What's for dinner?"

Getting the most from this book

If you're ready to make that kind of change but you need some inspiration, this book is for you. It's loaded with ideas, suggestions, exercises and examples to get you started. This book is not meant to teach techniques, but rather to strengthen your understanding of the fundamentals and open up your artistic expression. My hope is that my few words of encouragement will inspire and motivate you to experiment, explore and challenge yourself.

Actually, I've organized this book so that it does take you through a brief overview of some of my essential tools and techniques before diving into the topics I think are most important for an artist to understand: values, color,

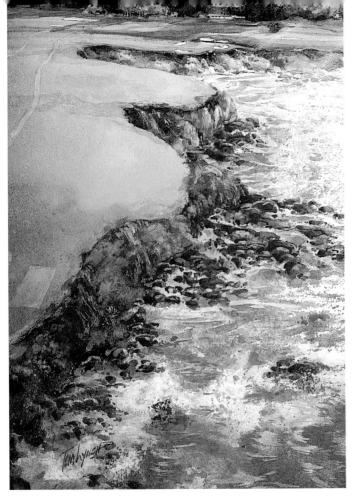

"Pebble Beach, 8th Hole" (30 x 22")

"Lincoln Park Lagoon" (22 x 30")

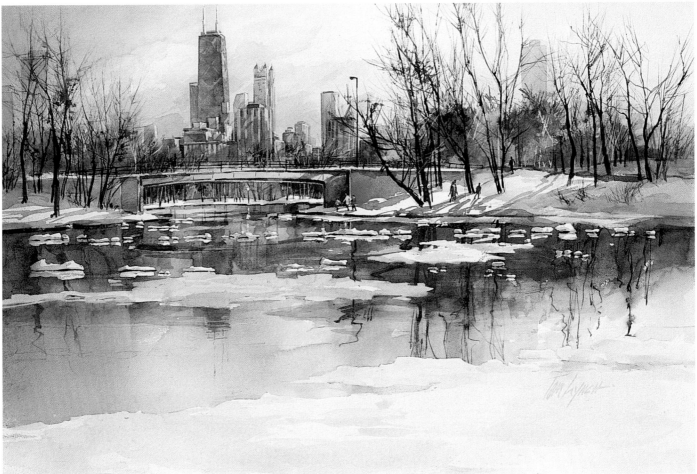

11

"Canterwood" (22 x 30")

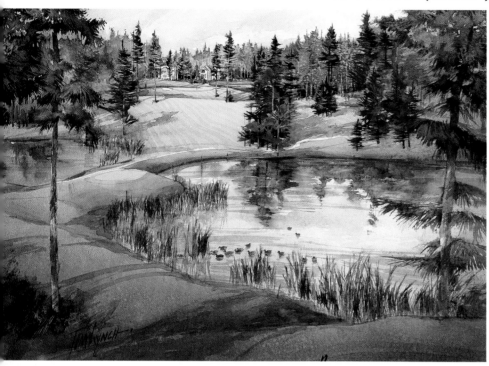

designing with shapes, impact area and expression. Along the way, I've incorporated some of the material I share with my workshop students. After explaining the topic of each chapter and providing some type of demonstration or illustration to further your understanding, I've included some typical exercises for strengthening your skills and shown how I "salvage" some of my students' works. Of course, each chapter begins and ends with examples of my work, and there are several more demonstrations and many additional studio paintings in the final section.

Before you begin, I'd like to give you this thought: Art is a journey, not a destination. Give yourself room to experiment, embrace the new look and your art will evolve into a true expression of yourself. You'll soon be able to use your art to make a positive impact on others. If just one person looks at your efforts and is enriched, stimulated or entertained, you and your art have done something important in life.

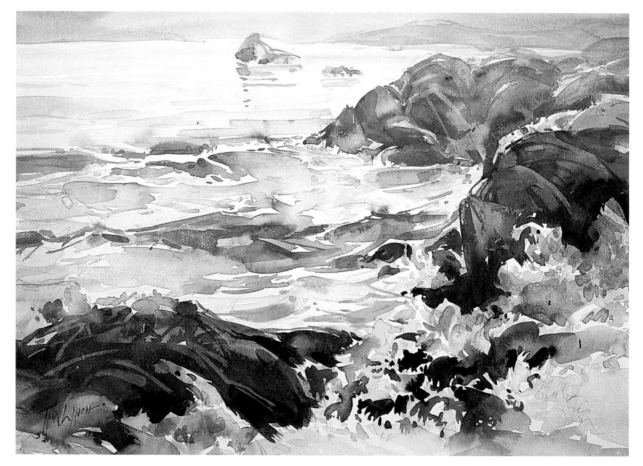

"Ocean Colors" (15 x 22")

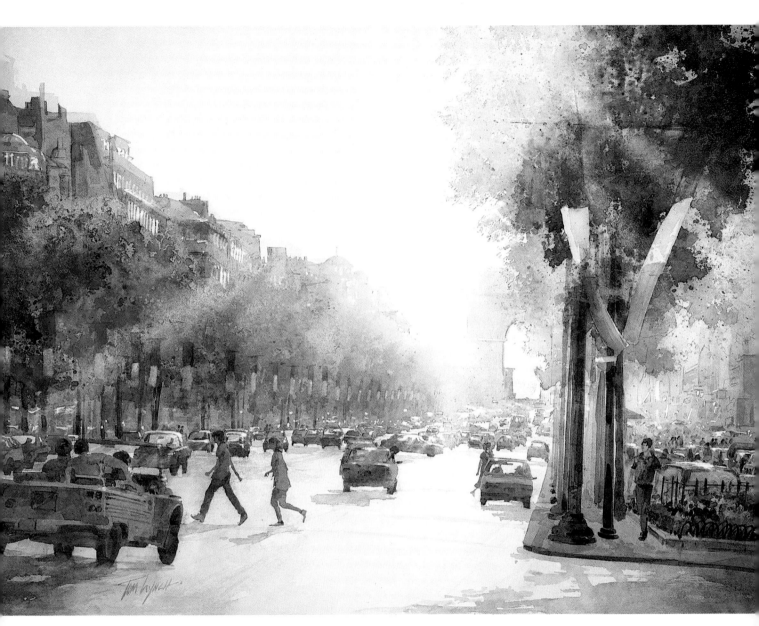

"Champs Elysée" (22 x 30")

"Art is a journey, not a destination."

Chapter 1

Techniques

It's important to learn different techniques, but don't let them become the focus of your art. Excite your viewers with your interpretation of a subject, not your technical prowess.

For many artists, the techniques they can pull off with watercolor are the whole reason they paint in this medium. For me, special techniques are a means to achieving an end. Don't get me wrong, they're a great deal of fun. But as you explore them, don't forget the purpose behind them. It's more important to capture an impression or portray a suggestion of a subject than to show off your ability to use a series of techniques.

So as you learn the techniques in this chapter, keep in mind the word "variety". Even if you embrace a "new" technique, such as applying color with a spray bottle, don't overload your next painting with only this new way. Combine the spray bottle technique with your "old" ways, such as sponging, splattering or drybrushing. Use all of the techniques that will help bring out the mood or message of your paintings. Remember, entertaining your viewers is always your number-one priority.

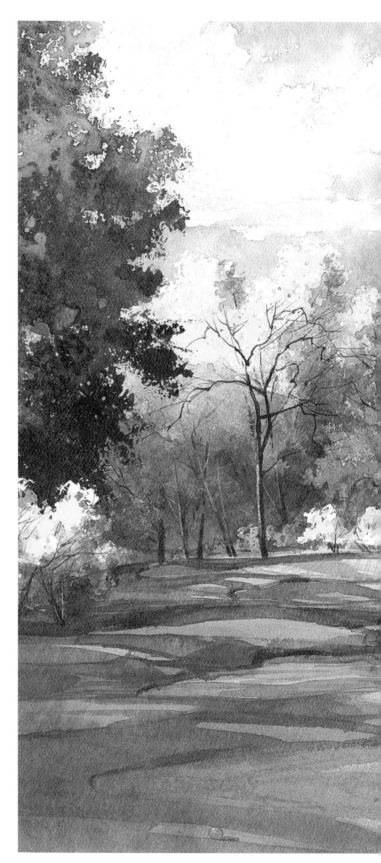

"Fall Classic" (22 x 30")

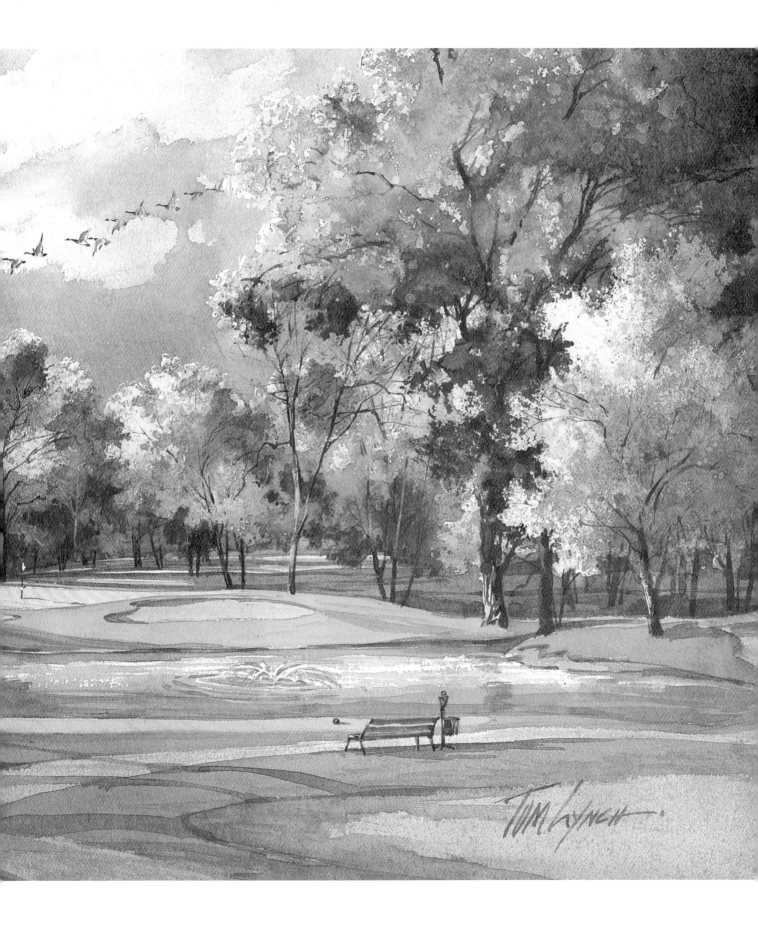

My favorite methods of Applying Paint

Heighten the effect of your paintings by using a variety of special techniques.

There are plenty of ways to get paint on paper, sometimes involving a brush and sometimes using other tools. This page demonstrates just a few of my favorite methods of applying paint, which I recommend practicing before trying them out in a studio painting. Once you've mastered them, though, it's easy to go overboard when you're using them in a painting. Remember to let one technique be dominant, and accent it with just a few others.

The flat brush, in a variety of sizes, is one of my favorite brushes to use because of its versatility. I suggest holding the brush at the far end of the handle and letting your arm and hand move freely, like a maestro conducting an orchestra. Practice painting with the side, corner and ends of the brush in strokes moving in all directions, even against the hairs, to see the variety of loose, seemingly random marks you can make. Experiment with the pressure of your hand for even more options.

Drybrushing is another great way to give a rough, uneven look to your strokes. Simply dip your brush in the paint, wipe some of the moisture and pigment on a sponge, then drag the brush over the paper. This sometimes happens naturally at the end of a long string of marks, which just adds more variations to that wash.

A long-haired round brush, called a rigger, is great for making branches and other long, wispy strokes. Painting with a dry brush or on dry paper sprayed with dots of water will achieve a broken, irregular, natural look.

A natural-hair brush is essential for splattering. To use this technique, load up your brush with lots of paint, hold the brush over the painting and firmly shake the paint onto the paper by making short, up-and-down hand movements. Another way to use this method is to hold the paint-loaded brush over your other hand, or another brush, and tap gently to bring the paint out onto the paper. This usually results in smaller dots.

Another easy way to make a rough, uneven texture is to dip a natural sea sponge in paint and blot it on the paper. Varying the pressure and the moisture content will make it look more interesting and less mechanical.

Only in Disneyland do trees have round, lollypop leaves! I've found that a great way to create natural-looking leaves is to put diluted color in a small, pump-spray bottle and "spritz" the paint out in little dots of varying colors. Add a light spritz of clear water on top of the color and those dots will be transformed into leaves. Misting on diluted paint with a spray bottle is also useful for toning down broad areas — particularly around a painting's edges — with a soft touch of color.

Learning more Special Techniques

A variety of approaches make this painting much more interesting.

I incorporated a number of special techniques into this painting, "Venice Reflections", which is one of my wife's favorites, to make it as entertaining and exciting as I could. These techniques helped me "showcase" or "symbolize" the objects in the scene — which is always my primary goal — rather than paint a literal representation of the subject. In addition to a variety of brushstrokes and dot spray applications, I used several other techniques demonstrated here to contribute to the overall effect of the painting. Again, mastering these techniques requires a little practice.

"Venice Reflections"

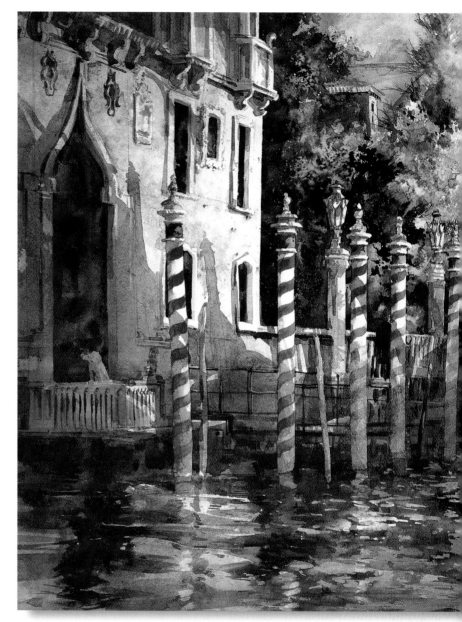

Making hard edges in less important parts of a painting can detract from the impact area. One way to soften a hard edge that's already dry is to take a brush loaded with clear water, brush it gently against a portion of the hard edge and pull the re-wetted paint into the clear water so it blends in with the surrounding area.

Liquid frisket is a handy way to preserve some white areas, such as these striped poles, without forcing yourself to be too careful or controlled. Use an old brush to paint (or even splatter) on the liquid. Once it's dry, you can paint over the area in loose, colorful washes. Later, after all the paint is dry, remove the liquid frisket by rubbing it off with a rubber cement pick-up. The one problem with frisket is that the masked areas always end up with a hard edge, so just take care to soften those edges somehow and weave the saved areas into their surroundings. For example, you'll see from the finished painting that I put in a second wash of blue over the water and brought it up onto the poles to tie them together.

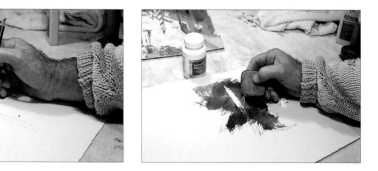

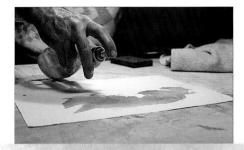

Edges are so important. A variety of edges, especially within the same object, make a painting so much more interesting. Besides using your brush to vary your edges, one of the easiest ways to achieve soft edges is to spray them while they're still wet with a few dots of clear water from a pump-spray bottle. In fact, when you're painting a large wash, stop every four inches or so to spray some parts of the edges with just a few dots of water, as I did when painting these clouds. Not only will this soften some edges, it'll vary your values and brush marks, too.

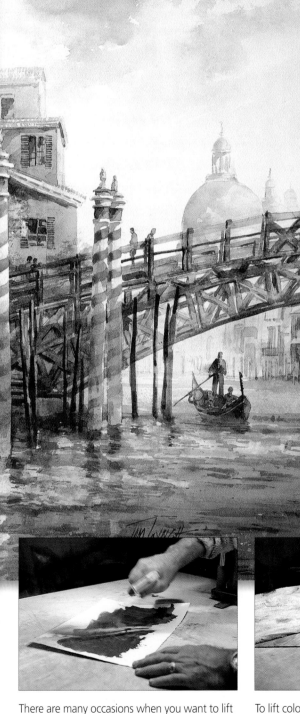

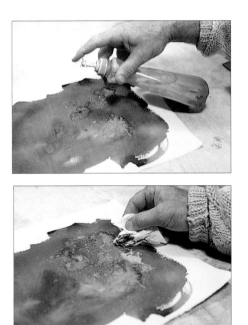

Watermarks, backruns, blossoms — some painters think of these as the enemy. But if you know how to control them, they can become another great technique for creating fresh, unique textures in the most familiar subjects, such as trees, weathered buildings, barns, rocks, roads, stones, forests and clouds.

The key to this technique is timing. Wait until the "shine" of the first wash has just gone away, but the paint is still damp. (The area should feel cool to the touch, even though no color comes off on your hand.) Then either splatter or spray dots of water only or water mixed with some color, preferably slightly lighter or darker than the initial color. The additional moisture will create a mottled watermark, which may be blotted with a tissue for even more variety.

There are many occasions when you want to lift dry color off a painting, either to correct an error, lighten a value or perhaps to suggest a special lighting effect. In this case, I wanted to create a mottled, speckled look in the distance to suggest the misty atmosphere and diffused light of Venice.

To lift color, use a trigger-spray bottle set on a wide spray (not a fine point) to moisten the dry paint, then blot with a cloth towel. Rub the paper, harder in some areas, more gently in others, to create an uneven variety in the remaining values, colors and edges. Just make sure your brand of paper can handle the abuse!

By the way, you can also try several other color-lifting variations. Use the trigger bottle and spray in a specific direction, guiding the paint and water off the painting to suggest "rays" of light. Or try re-wetting the paint with a brush or spray bottle, and try blotting with a tissue.

Gathering your Tools

Use good quality stuff and you'll be able to concentrate on expressing yourself.

Here's an explanation of the materials you'll need for many of my special techniques and effects. In some cases, I've recommended specific brands that I feel are best suited for my working methods. But remember, materials should be secondary to the expression and joy you wish to project.

Backing board
I like to back my watercolor paper with pieces of Foamcore board (a styrofoam-filled board with heavy, coated paper adhered to both sides) because it's portable, lightweight and non-porous. If you're using a 140lb paper or lighter, you can even stretch your paper on Gatorbord by stapling into it. After soaking the paper for 20 minutes, lay it on the board and staple around all four edges, placing the staples about ¼" apart.

Pencil
A mechanical pencil with a .5HB lead always gives me a sharp point for drawing.

Frisket (liquid and film)
Frisket is great for protecting certain areas of highlights while applying big, wet, loose washes. For liquid frisket, I prefer the White Mask brand because it dries clear and is less confusing than the pink, gray or yellow brands. This brand supplies an applicator called an "incredible nib", but I also use an old natural-hair brush for painting on frisket. This brand is so thin, it can even be sprayed out of my spray bottle in tiny dots. Frisket film comes in big sheets, which is better for covering large areas than the liquid frisket. The film is easy to cut, so you can cover only those areas you want to temporarily preserve.

Paper
Besides brushes and paint, paper is one of the most important components in painting. Since many of my techniques involve rubbing, blotting, scrubbing, spraying and lifting, I require a paper that keeps the paint on the surface at first and holds up to a lot of abuse, then still accepts a smooth wash after it dries. Thus, I've found that Gemini, Imperial, Lana and Wyeth papers, typically in the 300lb cold-pressed finish, are the most compatible with my methods.

Spray bottles
I keep dozens of these little items on my work table, but there are basically three types of bottles I use. The trigger bottle has an adjustable stream of water for removing color if you make a mistake, or for spraying off a ray of light from the sun or a streetlight. I use a pump-spray bottle with water in it to soften an edge, lighten a value or adjust the mark made by my brush. The perfect pump-spray bottle should emit about 10 dots of different sizes with each light touch. The third bottle type is also a pump-spray, but it has two different tops — one for emitting just a few "dots" and one for "misting". I keep lots of different colors and color combinations, mixed with varying amounts of water, in these bottles so I'm always ready to alter a small area with a few dots of another color, or subdue a larger area with a subtle mist of color.

Sketchbook
I prefer books of 140lb cold-pressed watercolor paper that are spiral-bound at the top.

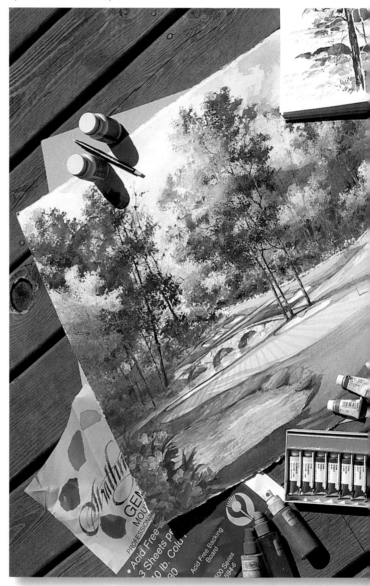

Paint
I've tried every make on the market, and I firmly believe there's a big difference between brands. I can honestly say that there's no brighter color saturation and no better consistency than the Holbein brand. The pigments remain wet in the palette, and when they finally do dry, they re-liquefy better than any other, which helps when you're lifting dried color off a painting. Their color range offers brilliant, vivid lights and deep, rich darks, and the colors remain bright when you water them down or mix them.

Other supplies

- Facial tissues for quickly blotting up color. Buy the kind that pop up from the box, and keep plenty on hand.
- Cloth towels for covering up parts of your painting or blotting up color.
- Cotton swabs for softening edges or cleaning up errors.
- Rubber cement pick-up for removing dry liquid frisket.
- Stencil paper for protecting the rest of the paper when you're spraying, misting or splattering color on one section of the painting.

- Razorblade to lift off color and leave a sparkle of light.
- Electric eraser loaded with an ink-erasing insert to remove dry color and create highlights.
- Sandpaper for roughing up the paper in certain areas to show texture.
- Hairdryer (1300 watts) for drying wet paint without affecting the color.
- Mats, in several sizes and colors, so you can check your progress and review your efforts objectively.

Sponges

Both natural and artificial sponges are useful for special effects when applying color and for drying out the brush and cleaning the palette.

Buckets

I use deep buckets so the dirty color will fall to the bottom, leaving a long-lasting supply of clean water at the top.

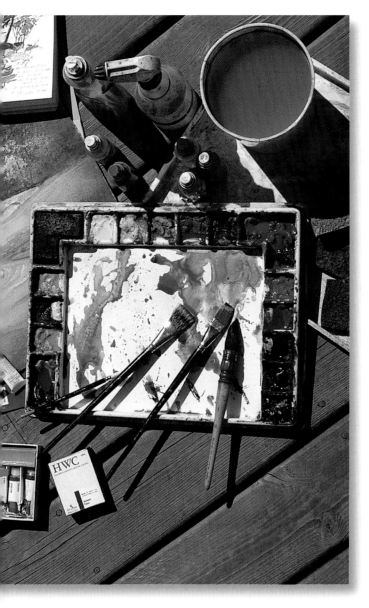

Brushes

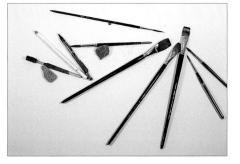

Good quality brushes are a worthwhile investment. The better the brush, the better the results and the longer it will last. The most important factor in a brush is the quality of the hair. To use most of my techniques, it's imperative to have 100% natural hair in your brush — the finest Kolinsky sable if you can afford it. Natural-hair brushes quickly absorb a lot of color out of the palette and then transfer a lot of color to the dry paper. With synthetic brushes, you're constantly struggling to transfer a wet wash from the palette to the paper.

You don't need a lot of brushes, only a few good choices. I use Raphael brushes because they have more, longer hairs for holding and transferring paint. Here's what I recommend buying: Series 905 (flats) in #20, #16 and #14, Series 8404 (rounds) in #6 and #8 and Series 8802 (riggers) in #6 and #8. If you can't afford the Kolinsky sable, a good option is Kevrin hair Series 8779 in #20 and #16 and red sable Series 8424 #6 and #8. I also like a 3" wide ox ear brush from Series 298 for large glazes, and the pony-hair mop brushes from Series 803. Even though I have roughly 50 brushes in the studio and carry only four on location, I usually rely on a handful of quality brushes for most of my work.

Palette

I designed my own palette, which I manufacture and sell, because I prefer a palette with an open center mixing area. Too many divisions in the mixing area often causes isolated color sections in the painting — something we all want to avoid. My palette also has deep, slanted wells so my brushes can easily slide in and pick up fresh color. Plus, my palette has a lid that keeps colors moist so expensive paints don't go to waste.

In-store testing

"When shopping for a brush, make sure the hairs are evenly shaped and that the 'belly' of the hairs (the section just outside the metal ferrule) is fatter and fluffier than the tips. Then wet the brush to make sure it holds its shape and springs back after you touch it to the paper."

Understanding my Techniques

Here I'll show you how I combined a bunch of techniques and an unlikely center of interest to provide excitement.

I've been the featured artist at the U.S. Open Golf Tournament four times. My golf art is well received because I look for unusual, different ways to handle this subject. Here, I purposely chose an unlikely area — a wave — to act as my center of interest, not the obvious house or putting green. Then I used a number of special techniques for stimulating visual effects.

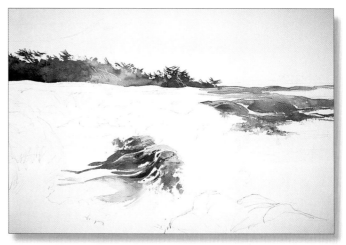

Starting at the center of interest
After applying liquid frisket on the sand traps and a few trees in the forest, I began by painting the impact area, establishing the best color, contrast and edges here first. I used a flat brush to make a variety of strokes, plus a little splattering. This area acts as a reference point for all other parts of the painting.

Layering for depth
Next, I considered which values to assign to which layers in the painting to achieve depth. After choosing a dark value for the distant trees, I laid in a colorful wash. I didn't think about painting the "parts", only that I wanted to see a variety of color and brushstroke as well as a consistent value across this area. I carried approximately the same dark value into the cliffs because . . .

Workshop Experience

"If you want to splatter an area without getting the paint dots all over your work-in-progress, try covering some areas with a stencil. I use a heavy waxed paper which I cut along the edges into a very bumpy, uneven pattern. The erratic edges of the stencil will allow the splattered paint dots to fall into a more natural-looking shape with uneven edges."

Lifting color for effect

I knew that a speckled, textured look would give the impression of a heavy mist hanging over the rocks and trees. The best way to achieve this look was to paint the area darker than I wanted it, use a trigger-spray bottle to spray off some of the color in the cliffs and blot/rub the area with a cloth towel. Besides varying the values, this technique resulted in a different "look" than simply a brushed-on lighter value.

Workshop Experience

"In general, I don't worry about small errors. Usually, trying to go back in to 'fix' something just ends up making it worse and more noticeable. But occasionally, there'll be a rough edge or stray paint dot in an unpainted area that needs to be tidied up. The best way to do this is to wet a cotton swab, gently rub out the unwanted paint and blot dry with a towel."

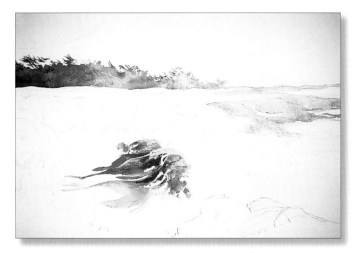

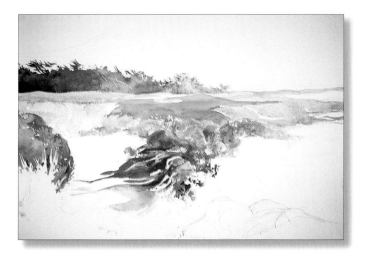

Connecting through value

The horizontal plane of the putting green needed to suggest depth, so I used a graded wash that went from a light value toward the back to a dark value near the front. I added touches of water to this wash just before it dried to create some watermarks, symbolizing texture in the rocks. Notice how the impact area is still most obvious, and the sprayed-off rock area is lighter than this wash.

"More than anything, I want to entertain my viewers by giving them something interesting to look at. And that means variety. The more techniques I use, the more unique my paintings will be, which will hold my viewers' attention longer."

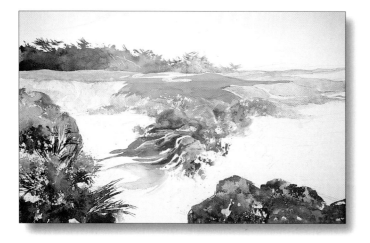

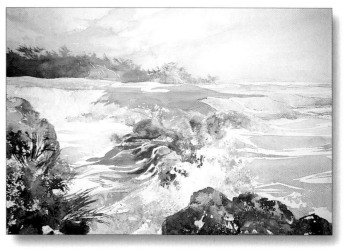

Moving to the foreground

Choosing a dark value for the close foreground shrubs and rocks, I used several techniques — a spray bottle filled with color, splattering, sponging and watermarking — to create textured "symbols" of these objects. As always, I didn't want to paint accurate recreations of rocks and plants, but rather to suggest or "showcase" the character of these objects. Notice how the difference in shape, color and value separates this layer from the objects further back.

Building support

I saved the two remaining horizontal planes — water and sky — for last so I could overlap them with the land objects, creating a more natural transition between the planes through unified colors and edges. In deciding which way to swing the values, I considered what would enhance the impact area. Since these are supporting areas, I wanted to keep their effect rather minimal, yet still interesting, so I used only a few dots of water here and there to add a touch of texture and soft edges.

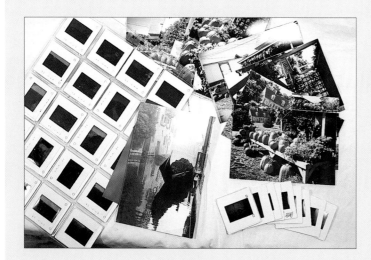

Viewing photo references

"I prefer to shoot slides, hundreds of them, of the subjects I like and find appealing. Then I can sort and catalog them by mood or subject for easy reference. I store them in clear plastic slide sleeves that hold 20 slides at a time.

To keep a slide ready for reference, I sometimes attach it to my work light with a sheet of white paper behind it for easier viewing. Occasionally, if I want to sketch or paint from a slide, I'll project it by inserting the slide into a projector and facing the projector right at me, at my work table. I then suspend a sheet of frosted acetate over my table, in front of the projector, to capture the image. With this approach, I don't have to work in a dark room."

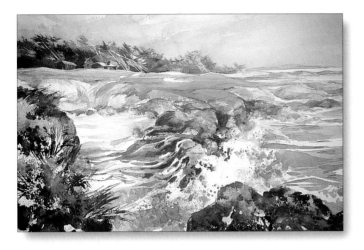

Looking for refinements

At this stage, the foundation of the painting was complete, so I placed a mat over it to see where I might make a few improvements. In doing any refinement, I always refer to the impact area, making sure it has the most emphasis and sets the stage for the amount of refinements made elsewhere. In this case, I decided to make the line of the distant forest a little more varied by lifting out shapes to suggest branches, trees and rooftops, but I constantly checked to make sure I wasn't detracting from the impact area.

Workshop Experience

"Some techniques rely on the paint being absolutely dry before continuing. To check the dampness of a painted area, touch it gently with the back of your hand. The least bit of coolness indicates that it's still damp."

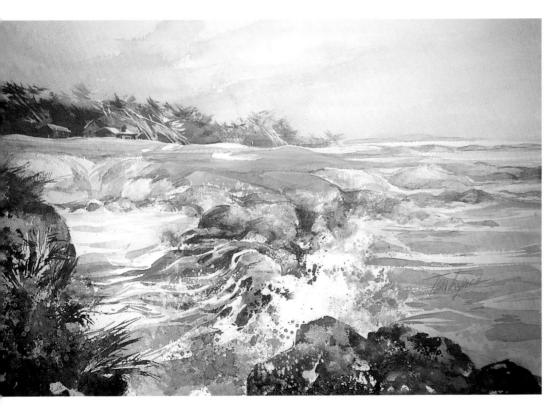

Adding the finishing touches

Finally, to enhance the impact area, I applied a fine mist of diluted Cobalt Blue to eliminate the white in the lower left and lower right corners and to darken the sky in the upper left, giving a better impression of light coming in from the right-hand side. I also used a razorblade to scrape some highlights in the water splashing up on the rocks, across the top of the rocks and on the water at the horizon. Before calling **"15th at Cypress" (15 x 22")** complete, I turned the painting upside down to see if any colors, contrasts, edges or details detracted from the impact area or stopped my eye as it moved around the painting.

Salvaging with Special Techniques

Here are a few ideas for reviving those dull paintings.

Although special techniques should be part of any painting right from its beginning, they can also be used to go back and transform a not-quite-there painting into something special. If you've got an unsuccessful painting hiding under your bed or tucked up in the attic, here are a few ideas you could use to revive it. Always feel free to take chances with your old paintings. You have nothing to lose and everything to gain.

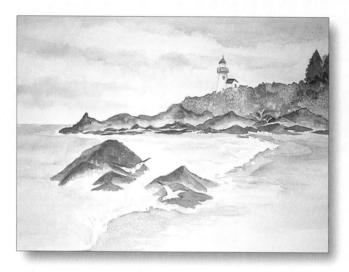

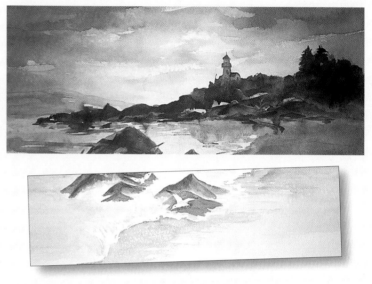

Weak color and value transition let this one down

One minor problem with this seascape was its centrally placed horizon line, which is easily fixed through simple cropping. More important, this painting needed stronger color and better transitions between values, plus something to pull the viewer's eye away from the obvious lighthouse.

As you can see, I cropped off the bottom of the painting and used a spray bottle to enhance the color and variety in the cloudy sky. A soft spray of color on all four sides brought out the more unusual choice for an impact area.

"Once you've mastered a few techniques, it's easy to go overboard when you're using them in a painting. Remember to let one technique be dominant, and accent it with just a few others."

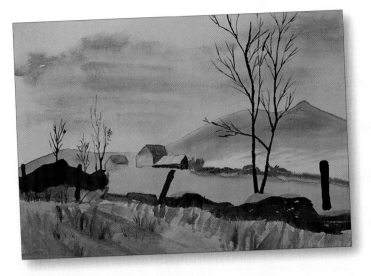

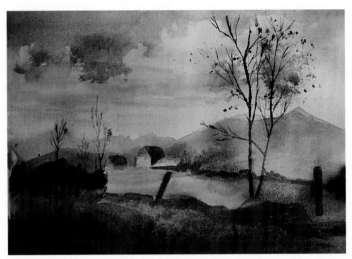

Weak impact area and lack of depth
This one had a nice variety of paint application in the trees, building and grass, but it had no clear impact area and little depth.

To make the house more prominent and push it back in space, I used a variety of brushstrokes to add layers of shadow and shading to the building, then used similar methods on extra layers in the foreground.

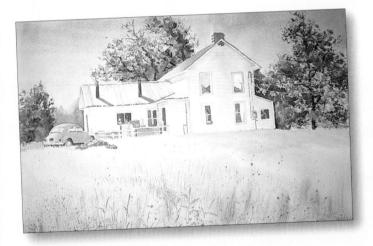

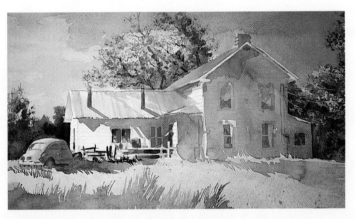

Disunity and weak impact area were the problems here
This classic farm scene needed more unified colors and an impact area.

I decided to emphasize the tree by splattering on some leaves. I then applied a glaze over the rest of the scene, adding drops of water from a spray bottle to vary the edges of the clouds. Pinpoints of red were the icing on the cake.

Showcasing Techniques

Entertaining my viewers is my number-one priority.

More than anything, I want to entertain my viewers by giving them something interesting to look at. And that means variety — the more techniques I use, the more unique my paintings will be, which will hold my viewers' attention longer. They'll realize they've never seen a tree or apple or whatever like mine before, and they'll be interested enough to explore it further. Using a number of different techniques allows me to create exciting representations or "symbols" of my subjects — not literal duplications showcasing techniques.

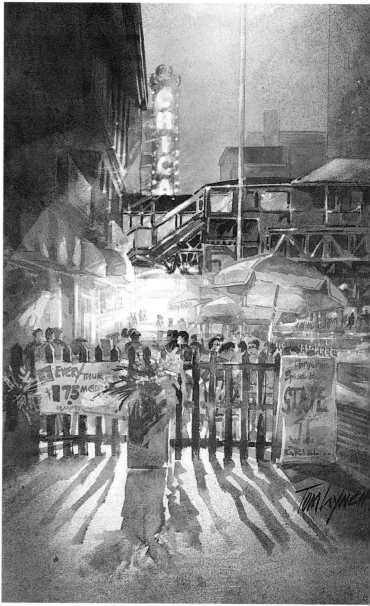

How a flat brush allows you to make different effects
A flat brush is such a flexible tool. For example, in **"PGA National"** **(22 x 30")**, I used a flat to create the soft-edged clouds, the linear strokes of the palm fronds, the drybrushed texture in the driveway and the broad strokes of color in the roofs and shadows.

Dazzling them with light
Sparkling lights bring **"State Street Café" (22 x 15")** to life. To create the larger "beacons" of light, I used a trigger-spray bottle to force the dried paint off in specific, ray-like directions. To lift the smaller pinpoints of light, I used an electric eraser with an ink-erasing nib.

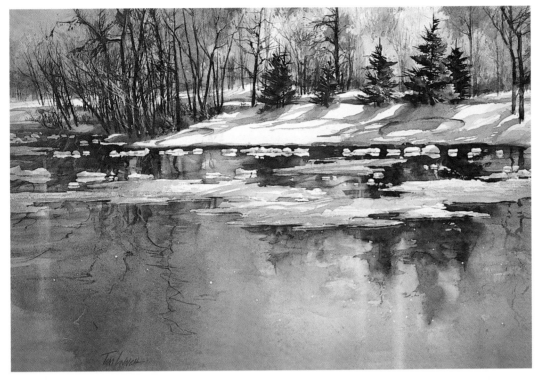

Carefully orchestrating techniques for balance
My painting **"Medinah Winter" (22 x 30")** is a careful balance between serene passages of snow and reflective water and busy areas of tree branches. The only way I could achieve this kind of diversity was by using a number of varied techniques.

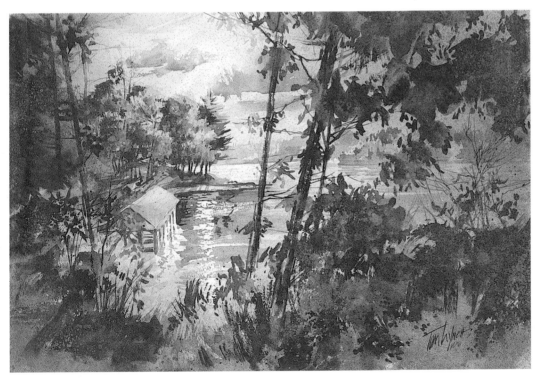

Compelling the viewer to come in
In **"Dillman's Lodge" (15 x 22")**, I wanted viewers to visually "come in and explore" this little cabin in the North Woods. To make the center of interest more inviting, I preserved some of the white of the paper in that area with liquid frisket. I also used a lot of textural techniques in the various types of trees surrounding the cabin to make the forest look dense. Last, I added a soft spray of Cobalt Blue at all four corners to eliminate contrast.

Chapter 2

Values

You might think detail is the key to grabbing your viewer's attention, but it's not. Contrast — either in value patterns or layers — will make people stop and approach your paintings.

I want my paintings to stand up and be noticed, to visually entertain my viewers and hold their attention. I've found that contrasting values, along with a variety of shapes and colors, are the three things that most entertain a viewer. When I want to make a painting more interesting, I put in attention-getting value changes — the more obvious the better.

"If you're going to use the layered approach, the first thing you have to do is divide your subject into layers."

"Autumn Road" (22 x 30")

30

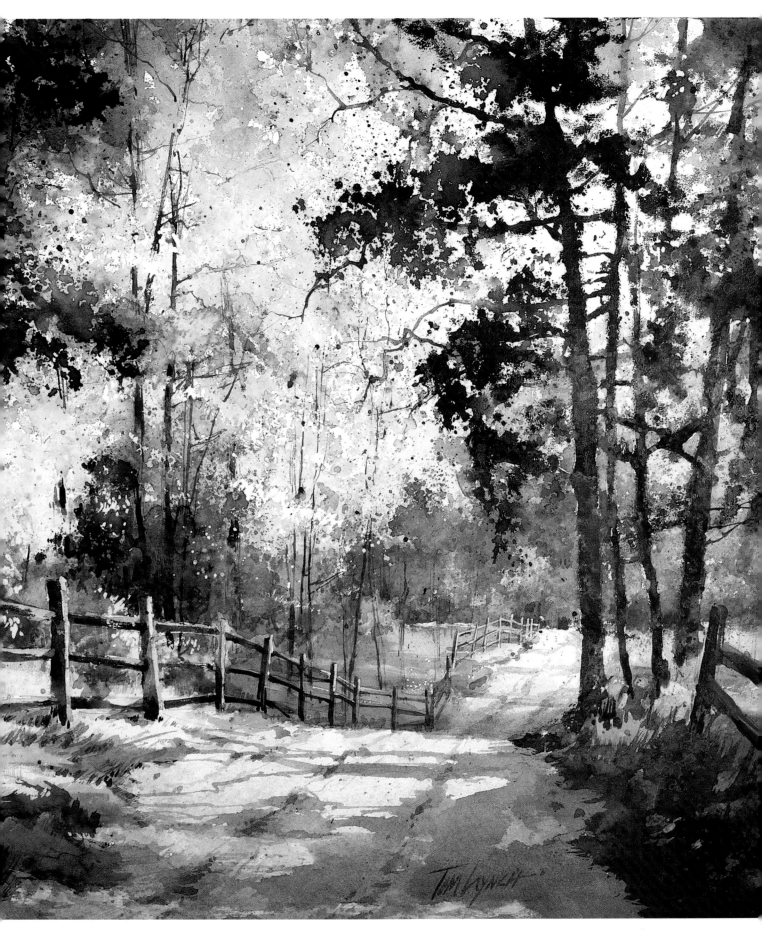

Understanding the idea of Values

There are two ways to use values — in patterns or in layers. It's your choice.

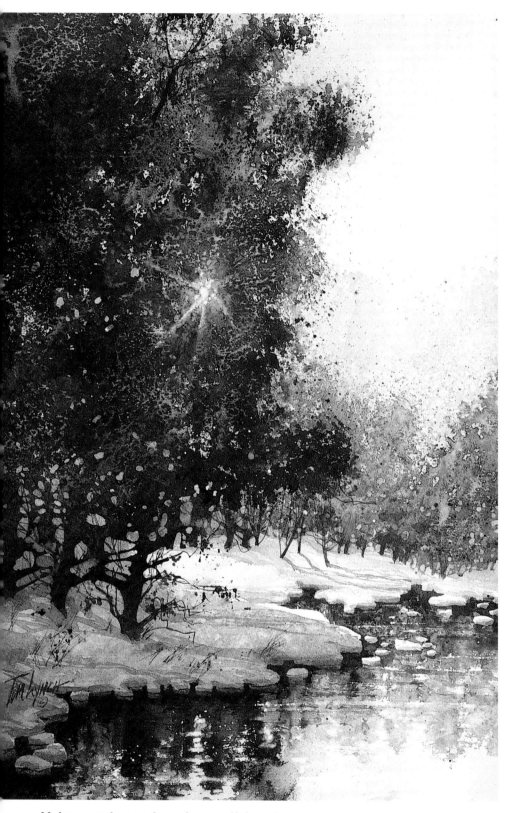

Values and mood — the traditional way
To create **"Winter Light" (22 x 15")**, I used a traditional layering of values. I thought this method was more appropriate for this scene, allowing the viewer to focus on the mood without being startled by an atypical arrangement of value changes.

Strong value changes between light and dark have been a hallmark of my paintings. I make sure I have a dominance of light and dark values, and put in the least amount of mid-tones. You can use contrasting values to add drama and intensity to your paintings, as well.

The best part of being an artist is that you don't have to copy the values found in your subject. Your job is to look at that subject and decide how you can go beyond the reference to alter or enhance the values. The more creative you are, the more your paintings will reach out to your viewers.

Before starting a painting, you have a choice to use values in one of two ways. One way is to have an alternating pattern of value changes — dark against light, light against dark — to distinguish the elements or shapes from each other. Generally, a close-up or lateral view of a subject, such as a still life, works well with patterns of light and dark. But if you're doing a scene that is panoramic, encompassing a lot of visual space, I recommend using the other way. As a student of the late, great John Pike, I learned the best way to show depth in a painting is to have layers of values. This means assigning distinctly different values to the foreground, middle ground and background to visually separate them from each other.

Many artists use this layering approach to show depth by making their values darkest in front and getting gradually lighter as they move back in the painting. I've taken this concept one step further. I think it's more interesting and fun to mix up the sequence and vary the number of layers, depending on the subject and the size of the painting.

A complex subject on a full sheet of paper, such as "Linda's Flowers", shown opposite, may have as many as four or five layers, with the sequence falling in any random order that looks good. However, a quarter-sheet painting should only have about two layers, and a half-sheet painting should have no more than three. Too many layers in a small-size painting will confuse the viewer, causing him or her to lose interest.

If you're going to use the layered approach, the first thing you have to do is divide your subject into layers. In every scene, you'll find that the different objects can be grouped into

Values and impact — the layered way

Extreme value contrasts always pull your eye right to the impact area. Notice, for example, how the bright light surrounded by dark values in **"Yvette's Café" (15 x 22")** grabs your attention.

either horizontal or vertical "planes" as your eye moves back into the distance of the scene. A vertical plane is an object (or group of objects that are all roughly the same distance from the viewer), that sit upon the landscape and have the ability to cast a shadow. You may decide to link these objects into two, three, four, sometimes even five separate groups. A horizontal plane is an object or group of objects that recede in space, such as the earth, water, road, grass, even the sky.

Your next step is to assign a value to each vertical group. Each horizontal plane should have a gradation of value. I recommend using thumbnail sketches to figure out all of the possible sequences of values you can assign, and to decide which looks best. In general, you'll find that the mid-values should be assigned to the least important layers, so that your most intense contrasts of lights and darks can be used in the more important areas, especially around the area of emphasis or impact area (see Chapter Five: Impact Area).

When you're ready to work in color, paint each layer in a single, colorful wash in the appropriate value. You should have at least three color changes in the overall area, but all three of the colors should be roughly the same value. Think "mass" or "silhouette", not individual objects, so that all of the objects in that group or layer are linked together. When you get to the section that includes your impact area, leave more white paper and use brighter colors in that area. As you put in the next group or layer, be sure to exaggerate the difference in values along the edges, where the two layers bump up against each other.

Eventually, you'll have covered all parts of your painting with colorful washes. It is essential to get them right on the first pass. Your highest contrasts should fall in and around the impact area, and your lowest contrasts should appear in the less important parts of the painting. If some area seems distracting, it may be that the values aren't quite right. Ask yourself if lifting a color or adding a darker value will improve it, then make the change before continuing. Above all, use your artistic touch to play the game of light against dark and dark against light.

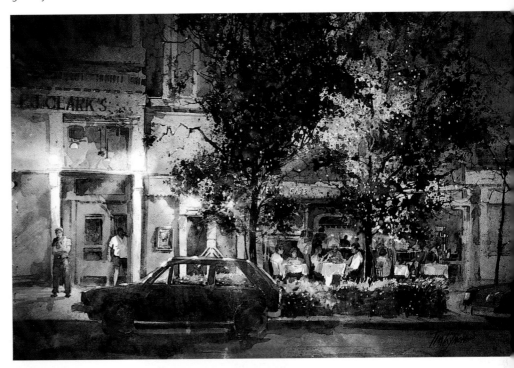

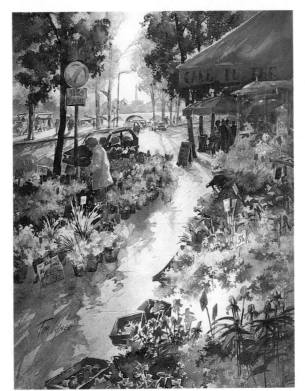

Layering Checklist

- *Divide your subject into layers.*
- *Assign a value to each group.*
- *Paint each color layer in a single wash.*
- *Think in mass or silhouette, not objects.*
- *Emphasize the impact area with brighter colors and more white paper.*
- *Exaggerate the difference at the edges.*
- *Make the highest contrasts around the impact area.*

Values and gradation — in random layers

Remember that you don't have to have the same number of layers across an entire painting. In **"Linda's Flowers" (30 x 22")**, I used three layers for the flowers on the left and five layers for the more complex elements on the right. Notice how I used the gradation in the sidewalk to show depth on a horizontal plane.

How to make Values work for you

In this demonstration, I'm using value changes to emphasize depth.

Since this village scene in Mexico is a panoramic view, I decided to use layers of value changes to emphasize depth. As you'll see, wherever two different values intersected, I exaggerated the distinctions and emphasized the contrasts to make those areas more exciting. They may look a bit strong at first, but these areas will merge into the overall effect after I've gone back for two or three more applications of paint, which I use to add contour, shape and form to the finished piece.

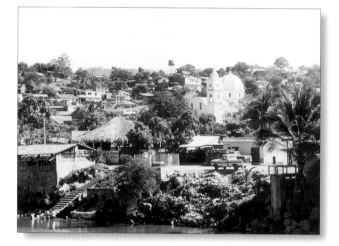

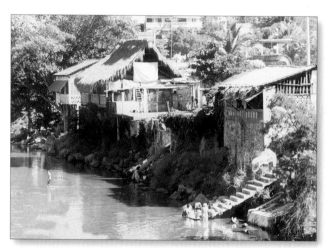

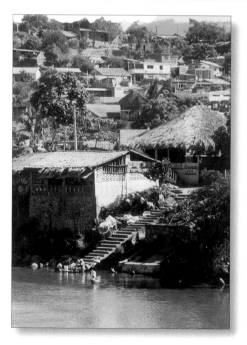

Evaluating photo references
Unless they're taken on a foggy day, most photographs have sunlit, shadowed and highlighted areas that are almost the same in value. Copying the values found in this kind of picture won't give the viewer a strong feeling of depth, so I used these photographs merely as a starting point for an arrangement of shapes and to provide information about the huts. The values and colors came completely from my imagination — after all, I wanted to create art, not just copy a photo.

"**Assign distinctly different values to the foreground, middle ground and background to visually separate them from each other.**"

34

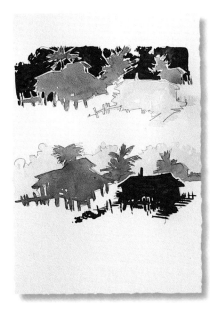

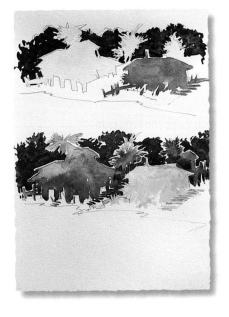

On personal style

"I hear so many artists discussing 'personal style', but I think it's important to develop many approaches and looks. It's a variety of styles that shows skill, not one complex style used repeatedly on every painting. This is why I stress developing all parts of a painting simultaneously, rather than working on one small area at a time. With this approach, if you've got a painting that's really working in its earliest stages, you can leave it alone as a simple, stylized or impressionistic piece. On the other hand, you may be in the mood to develop that painting further with more detail and complexity, still maintaining unity through all stages of development. The choice will be yours, and the results will be varied and unique."

Experimenting with values

Using nothing but Payne's Gray and some water, I created a few small thumbnail sketches to establish where the foreground, middle ground and background layers would be. In each case, I experimented with a different sequence of light, medium and dark values. Eventually, I decided to use the more creative arrangement of light in front and dark in back. I made a color thumbnail to determine how my value layers would look in color. This is a practice I learned from many of my teachers along the way, and I still recommend these invaluable steps to my students today.

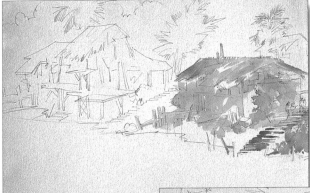

Starting with the lights

Ignoring the water (a horizontal plane) in the immediate foreground, I painted the complete forward layer in a light value wash using a variety of light, bright colors. As I painted, I thought about where the impact area was going to be, so I left more white paper and used brighter colors there.

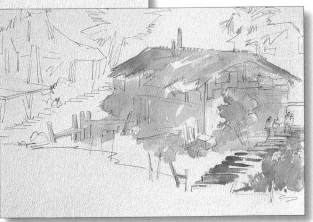

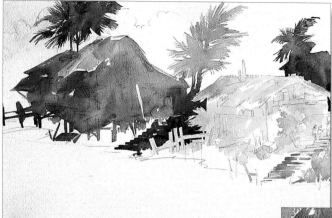

Switching to the mid-values

After making sure my lightest area was completely dry, I started to paint a variety of fresh, clean mid-value colors across the second hut, my middle layer. I was conscious not to be careful and paint "parts", meaning I treated this layer as a single mass of various colors in the same value. I left some white along the edges, knowing I could darken them later if they were too distracting. For the most part, where one value came up to a different value, I made the contrast between the two more pronounced. In some places, the middle value actually looks more like a dark value, but I never let it go too far.

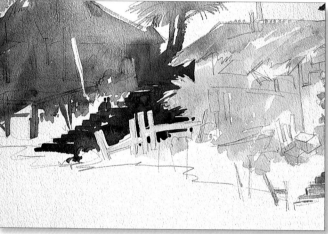

Going for the darks

Again, I waited until the mid-value section was dry before applying the darkest darks, occasionally leaving some white spaces between areas. As before, I also emphasized the contrast in the values where a dark bumped up against a mid-value. I believe that the value contrasts should seem most obvious at the point of intersection between two separate layers. But I had to use my judgment to avoid creating an overly dark area or an overly large quantity of darker color. You can now see how the changes in values clearly separate the three layers of space.

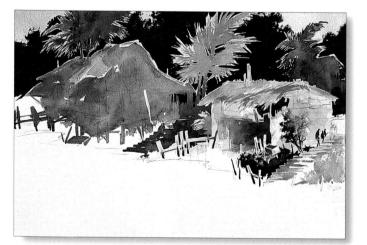

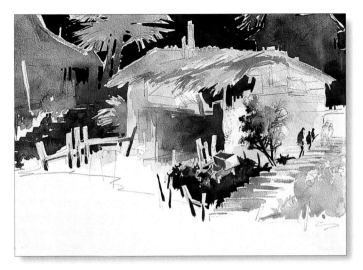

Striving for impact

You'll see in this detail that as I started in on my second application of paint, my goal was to clarify some individual shapes within each area. I began with the impact area and worked out from there. Since extreme value contrasts will automatically draw the eye, I went in with very dark values over the lights to define the interior of the hut, show the steps and suggest some figures. Before going any further with this small area, I decided to work on the rest of the painting so that the shapes, colors, contrasts, edges, detail and so on, would all harmonize in the end.

Shaping and contouring

Next, I moved to the middle ground layer done in mid-values. I added some darker values and lifted off some color in other small areas to carve out contours. With each refinement, I made sure the contrast wasn't as extreme so this area wouldn't detract from the high contrast in the impact area.

My 'rule of thirds' ensures clean washes and prevents overworking

"It's so easy to overdo things, making your shapes too busy and your colors muddy. So I've developed a system for keeping things simple which I call the 'rule of thirds'. When I apply a second layer of paint over a first wash, I cover either one-third or two-thirds of that first wash area, leaving the rest untouched. Even more important, once I have two layers of color on top of one another, my third application covers only one-third of the area. As an example, look at the before-and-after pictures of this palm tree. Note that in my third application of paint, I covered only one-third of the tree to add variety to the color and make a needed change in value. Following this theory will give you the discipline to keep yourself from overworking your paintings."

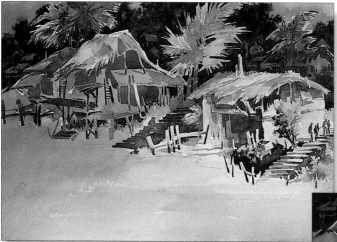

Moving to the edges

Finally, it was time to put in the horizontal planes of the sky and water. I chose the values for these areas based on what would enhance the impact area. I felt it would be best to make the water lighter on the right — where it would lead the eye to the area of emphasis — but slightly darker in the back and on the left to add variety and harmonize with the second hut. These variations were essential for suggesting depth. I painted the sky darker along the line of trees to minimize the value contrast there, but allowed it to become lighter at the top of the painting.

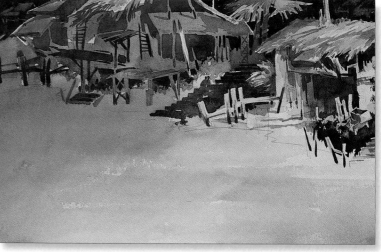

"Think 'mass' or 'silhouette', not individual objects, so that all of the objects in that group or layer are linked together."

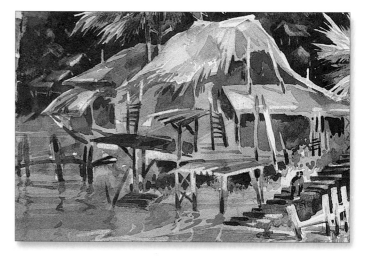

Closing in on the finish

After my second application of paint was completely dry, I went in for a few minor strokes of color here and there to add a few details to the more important areas of the painting. As always, I reminded myself to "keep it simple". Shading and shapes, not detail, make a painting succeed.

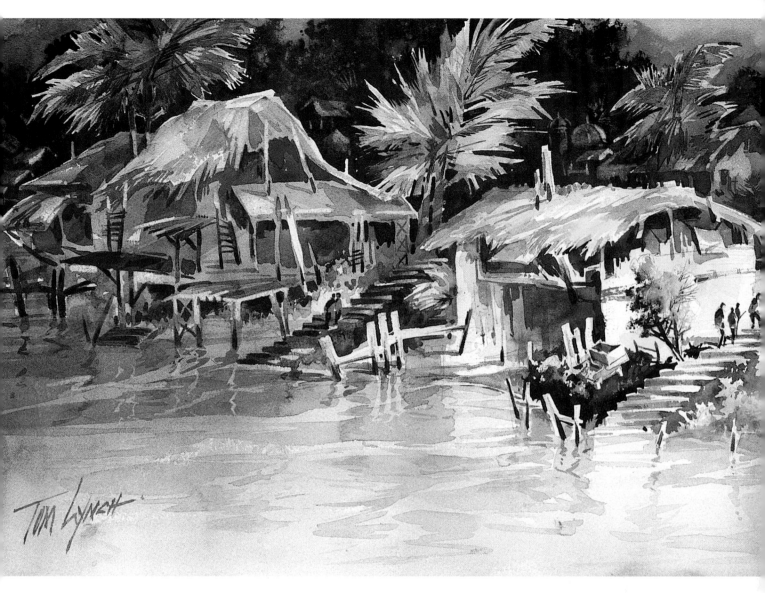

Workshop Experience

"So often, we think that adding details will make a painting more interesting. But most often, details just end up dividing the painting into separate, disjointed parts. Layering values is the key to creating depth, unifying a scene and making a painting more entertaining for viewers."

Making the colors pop

To complete **"Mexico Village" (15 x 22")**, I added a few light washes over the water to give this large expanse of space more interest and color, as well as softer edges.

On Location: Value Sketches

This exercise will help you improve your ability to create depth through values.

Understanding values is so important that I devote an entire day of my week-long workshops to the topic. One of the most useful exercises I give my workshop students is to paint value sketches such as these shown here. I recommend doing this exercise at home, too, spending about an hour at a time on improving your skills.

For this exercise, you'll need a subject you especially like — preferably a landscape — plus your sketchbook and either some black paint or a dark sketching pencil. You're going to make three value studies.

1. Start by drawing three 8 x 10" sketches showing the main shapes in the subject.
2. In your mind, group the individual objects in your scene into three groupings, or planes.
3. In each sketch, assign a different value to each group and fill them in with the assigned values. Be sure to alternate or vary the sequence of dark, medium and light values, as I did in my three sketches.

For advanced students

More advanced painters can create value sketches in color. Just remember, the colors used are not as important as the values. Values link objects and separate those groups from other groups, thereby creating depth.

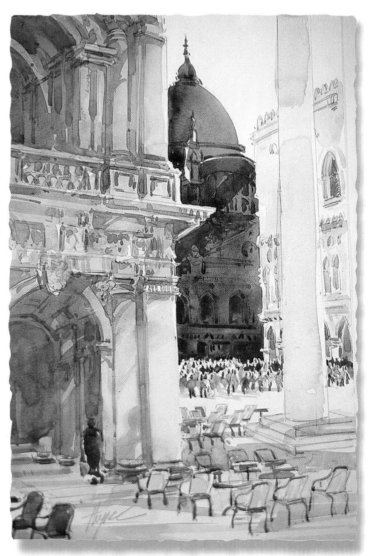

"When I want to make a painting more interesting, I put in attention-getting value changes — the more obvious and noticeable, the better."

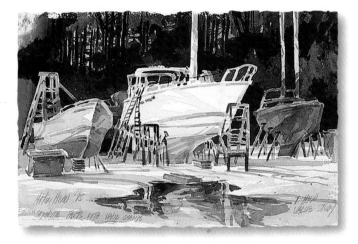

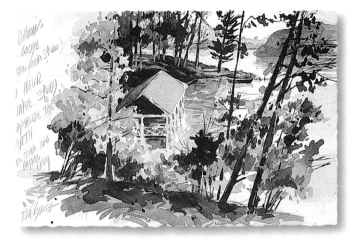

Set the stage for smart value choices

Three value studies aren't always needed to design a painting, but I suggest you make at least one preliminary 8 x 10" or smaller value study before starting a new painting, especially if you want to show depth. Here are two examples of my value studies done on location.

Workshop Experience

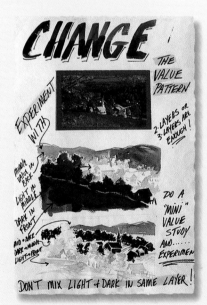

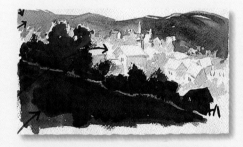

"Here's a chart that emphasizes the need for changing values in the different layers of a painting. For example, you may want to create depth by using a light-medium-dark sequence or a dark-medium-light sequence as you move from front to back in the painting. It's also okay for you to use your creativity and mix up the sequence of your layers. Look at how interesting and deep this little sketch looks with a dark-light-medium-light sequence.

The more interesting and varied your sequence of layers, the less you'll need to rely on detail to add interest."

Using Value as a Salvage Technique

Are you hiding a terrific painting in the mid-tones?

One of the most common mistakes I see artists making is failing to have enough variety in the values and leaving out the super-darks. Look at these examples to see how terrific paintings were hidden in these mid-tones. All I had to do was enhance them with stronger value contrasts (light versus dark) and finish them off by adding some strategically placed super-dark values.

Values lack variety
This artist did a good job of separating foreground from background with value changes, but there is no variation within the repeated columns.

In my revision, I created a variety of values across the three layers to add interest. Then I broke down the brick walls and archways in the background into more distinct values, again to add interest.

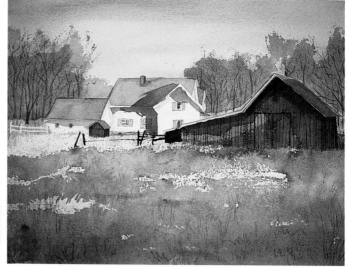

A flat, lifeless look
The lack of changes in the foreground of this painting make that area look flat. Likewise, the absence of shadows around the house and barn flatten those areas as well.

Look at the depth I achieved in the same painting when I made the immediate foreground significantly darker and put in dark-valued shadows around the house and barn.

"One of the most common mistakes I see artists making is failing to have enough variety in the values and leaving out the super-darks."

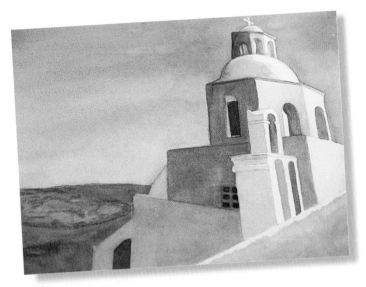

The center of interest has been lost
White objects, such as this Greek church, can get lost in a light background.

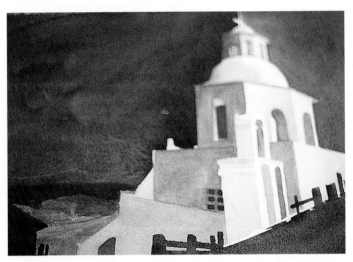

Look how putting a dark value in the sky and background makes this light object jump out of the picture and grab your attention. A bold move can really pay off.

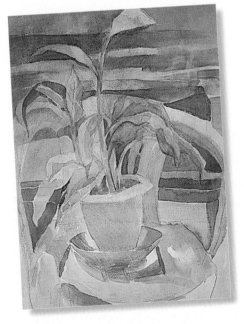

A problem with depth and pattern
Overly similar values turned this still life into a flat pattern of random shapes.

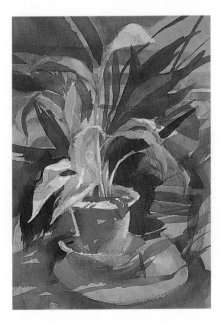

I used darker values to separate the plant from the background, thereby creating more depth, and to add a more interesting pattern of shapes to the piece.

Showcasing Values

I alter and enhance values to suit my purposes, whether it be to lead your eye, create depth or add interest.

When used in a traditional sense, layers of changing values can bring tremendous depth to a painting. Playing with values also allows me to create more unusual, non-traditional paintings, too. I like to have fun with values, and see what kind of excitement I can bring to my paintings by experimenting with unusual patterns or sequences of lights and darks. My motto is "take a chance and see what happens".

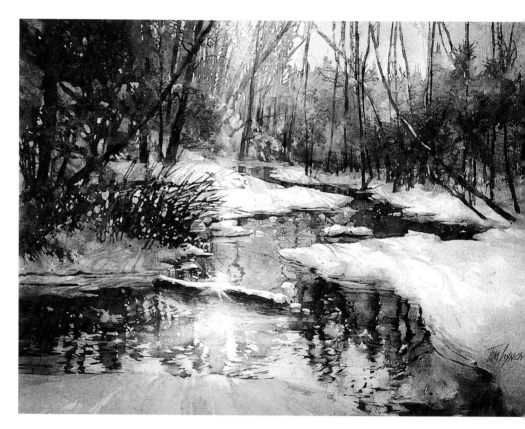

A good example of how values lead the eye
When used for effect, values can lead your eye right into the heart of a painting. Notice how the light values of the white snow patches act as stepping stones through my painting **"Winter Stream" (22 x 30")**.

Using atypical lighting like this will knock their socks off
Now and then, I like to knock the socks off my viewers with a bold change in value by using atypical lighting on a typical subject. Who would expect to see a nighttime still life? This painting called **"Still Life Patterns" (11 x 15")**, is about contrast and patterns of light and dark. Viewers are unlikely to say, "Nice basket — it looks just like the photo". I painted the whole sheet with an almost-black mix of paint, then lifted color in the light objects by re-wetting the paint, then rubbing and blotting with a cloth towel.

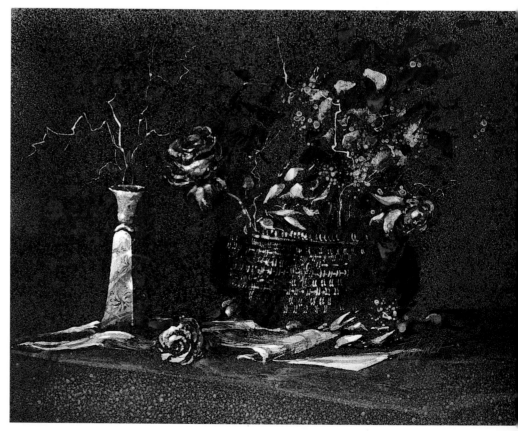

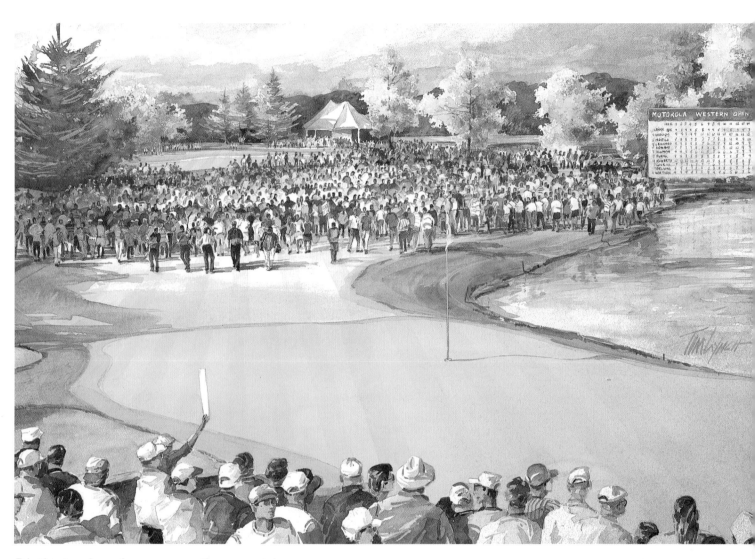

Distinct value changes are the secret here

As always, detail and attention to the separate parts don't show depth. The secret to the incredible depth in **"Victory March" (22 x 30")** is the gradual, yet distinct, value changes, especially in the layers containing Tiger Woods, the massive crowd following him and the trees and hills in the far distance.

Chapter 3

Color

Why be predictable? Instead, choose the unexpected, use bright colors and include plenty of variety.

Have you ever heard someone say, "I could look at this painting for hours"? What makes someone enjoy a painting that much? In my experience, one of the key factors is color. Bright colors make a painting come alive, a variety of colors make it more exciting and unexpected colors make it more interesting. As the artist, you have the power — and the choice — to bring that kind of entertaining color to your viewers.

Below: **"Late Round" (22 x 30")** Right: **"Monet's Door" (22 x 15")**

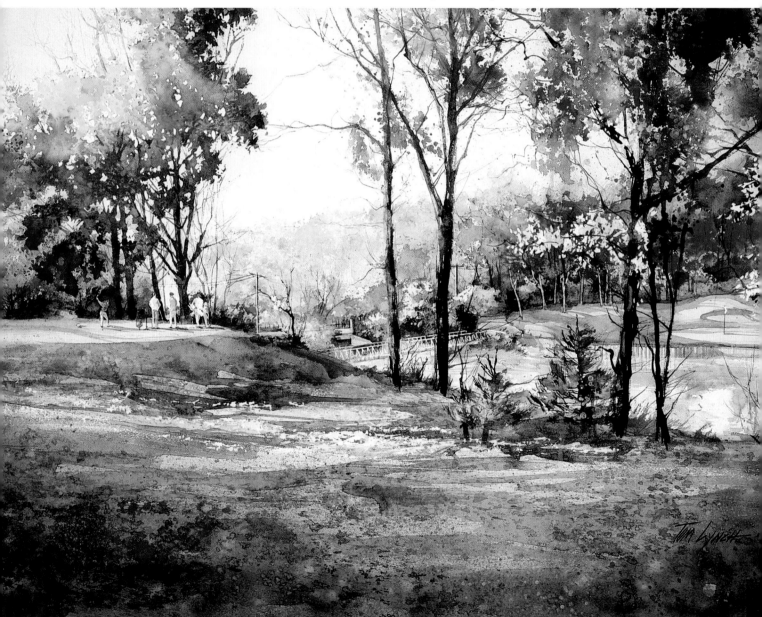

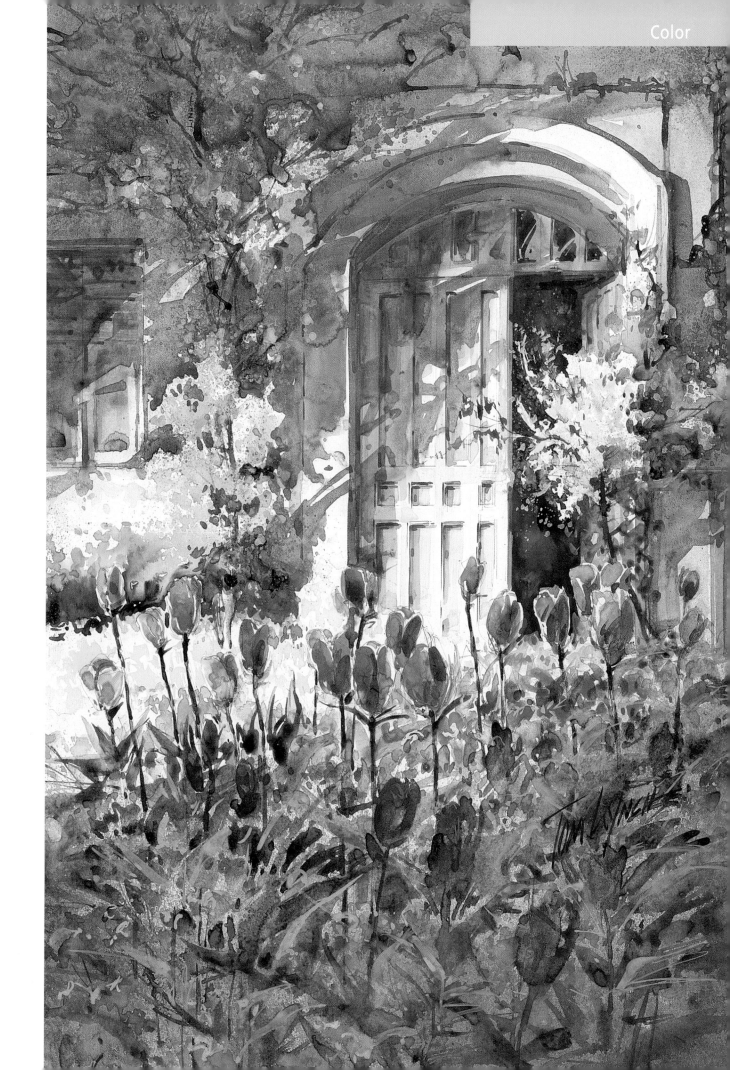

Understanding my kind of Color

You can get instant results by using vivid, unusual colors.

Any subject can be brought to life by using a wider range of color than you'd normally expect to see. Take a look at the following examples to understand what I mean. In each set, I've shown you a "nice" portrait of the subject, copying the colors exactly as they appeared in my photo reference. Compare these with my artistic display of the object in which I've varied the colors, tones and values to a much greater extent. In every case, the colorful version grabs the attention more than the "real" one. To me, this is the difference between painting and making pictures.

To become more comfortable with bright color, try this exercise: Choose one object from the next painting you're about to undertake, and experiment with painting it in the most colorful way you can, not the way it looks in the photo or even in real life. As you paint, make sure its color changes at least every inch, getting slightly darker, lighter, warmer, cooler, brighter — somehow different to what's right next to it. Remember to wash out your brush after each stroke to keep your colors clean and fresh.

Color changes are best when they come from varying your application techniques too, (see Chapter One: Techniques). For instance, spraying or splattering bright color over a wet wash will result in great color changes. Just keep those differences and variations coming!

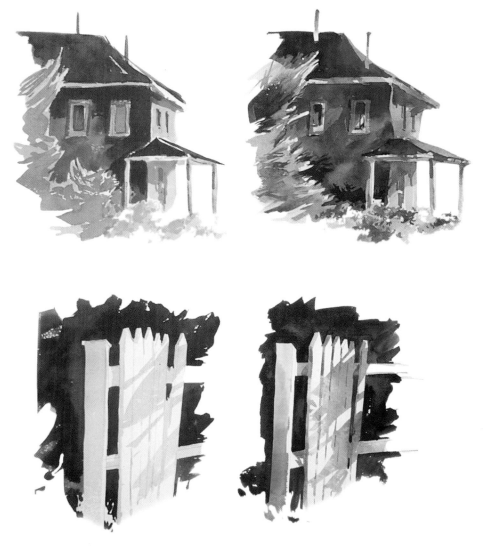

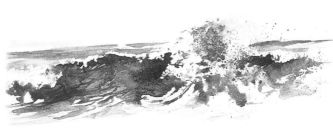

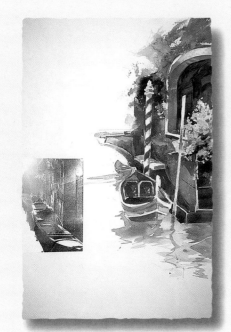

Workshop Experience

"I encourage you to try painting from black-and-white photos or from black-and-white photocopies of color references. Doing this forces you to see only the shapes and value changes in the composition. When it comes to applying color, you'll be free to open up and let go! Otherwise, painting from the color photos in front of you will hold you back from achieving a bright, colorful look."

Choosing and mixing Color

Think loose, lively, fresh strokes of exciting color.

Let me explain my palette. I begin by selecting the brightest colors the manufacturer makes because it's far easier to gray down a bright color than it is to brighten up a dull color. Then I select three different values (light, medium and dark) of each major hue. So my current palette includes: Permanent Yellow Lemon, Aureolin, Permanent Yellow Orange, Permanent Red, Permanent Magenta, Opera, Cerulean Blue, Cobalt Blue, Ultramarine Blue Deep, Peacock Blue, Royal Blue, Yellow Ochre, Permanent Green #1, Permanent Green #2, Hookers Green and Burnt Sienna, [all made by Holbein]. These pigment choices are constantly changing, but in general, I avoid staining colors and colors that are opaque.

I don't have a specific order for the placement of colors in my palette. At one time, I had my colors arranged like a color wheel. Other times, I've had warm colors on one side and cool colors on the other. My current arrangement actually has no particular meaning or purpose in mixing color. No matter how they're arranged, though, I make sure each well is fairly full of pigment so I can be generous in mixing color.

When I'm ready to start painting, I think about the most exciting colors I can use for my subject. I also think about the colors I'd like to see in the entire section of the painting I'm working on, such as mostly warms or cools. I mix up all of the variations, including the accent colors, observe how they look together and decide if that color scheme is going to work.

Then, when I start putting that paint to the paper, I can forget about the subject and the "right" colors, and just think "loose, lively, fresh strokes". Taking care of color choices ahead of time frees me to focus on creatively applying the paint in varied brushstrokes on the paper.

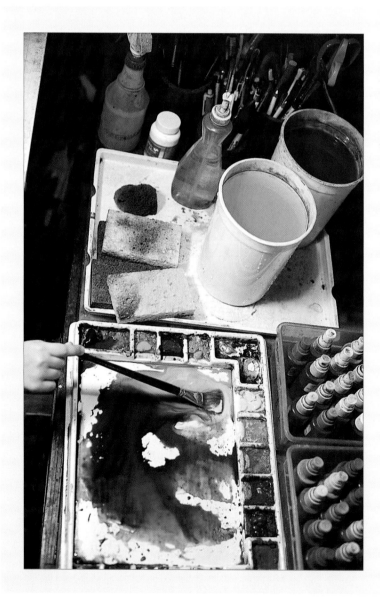

Color Mixing Tips

"Clean, fresh color is essential to my way of working, and I do several things to keep my paint clean. First, I keep a large, deep bucket of water (plus a second one as a back-up) next to my palette. When I go back to the palette for a new color, I wash my brush in the topmost portion of water in the first bucket (not the bottom where all the old paint has settled), and occasionally touch the brush to a damp sponge to pull out some of the moisture before picking up fresh color. These methods mean my brush is always clean when I mix up new color in the palette.

One other tip: When I'm mixing paint with water on my palette, I flip my brush over once or twice to make sure I get all of the pigment out of the brush hairs so it dissolves in the water."

Juice colors

The brightest colors on my palette are Permanent Yellow Lemon, Opera, Permanent Green #1 and Peacock Blue. I call these almost fluorescent pigments my "juice colors" because they're juicy and rich, brighter than other brands! I like to use them in my impact area in their pure form or mix them with other colors to brighten up similar hues in non-impact areas.

Shadow accent

When painting shadows, I find Peacock Blue, occasionally mixed with Opera, adds a little richness to shadows and provides a nice accent to the other colors used.

Extra green

My palette already contains three pre-mixed greens which I vary by adding yellows, blues and other colors. But I've found an extra way to make a beautiful green by mixing Peacock Blue with Burnt Sienna. A mixture that leans toward the Burnt Sienna makes a great green for desert pines, while leaning toward the Peacock Blue is just right for deciduous Northern Pacific trees.

Specialty colors

I've been having fun with gold and silver metallic watercolors and, more recently, with iridescent medium. These look great on white paper and even better over or under a dark wash. Two other special colors I use occasionally are Brilliant Pink and Lavender.

Darks and super-darks

Contrast is a key component in creating exciting color, especially the contrast of white paper next to a rich dark. My darks are typically various combinations of any two of these colors: Royal Blue, Ultramarine Blue Deep, Permanent Magenta, Hookers Green and Burnt Sienna. If I use three together, two of them are Royal and Ultramarine. All of these combinations remain clean-looking and transparent.

Then there's my "super dark", used only for the absolute darkest accents in the image. It's a combination of Royal Blue, Ultramarine Blue Deep, Hookers Green and Permanent Magenta. Sometimes I'll add Burnt Sienna to this mix. This is obviously very dark, but is far more rich and colorful than neutral tube colors such as Davie's Gray, Neutral Tint or Payne's Gray.

Unifying through Color

Letting your colors flow into each other will tie your painting together with one unified wash.

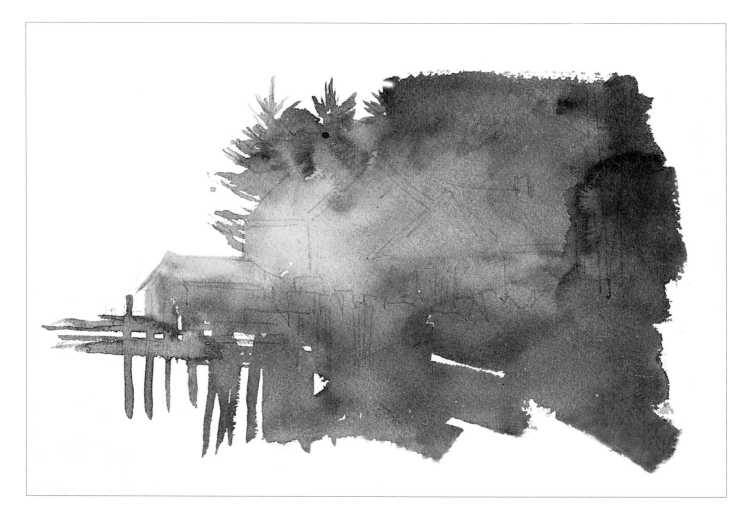

A variety of bright, bold colors eliminates the need for detail and unifies the whole painting. Just look at the three main illustrations on these pages to see what I mean. The adjacent picture shows the way many artists paint. They address each object separately, using the appropriate colors, but the end result is a series of unrelated pieces that just look busy. There's not much you can do to pull this together.

Now look at the picture above it. That's the kind of bold, bright wash I strive for in my first application of paint. When I'm painting this way, I don't think about the object I'm painting. I just try to make it loose and exciting, letting the colors overlap and flow into one another. With this as a foundation, I can go back in and add a minimal amount of contouring, shadows and details, and end up with the third picture opposite, a lively, interesting painting that's unified by color.

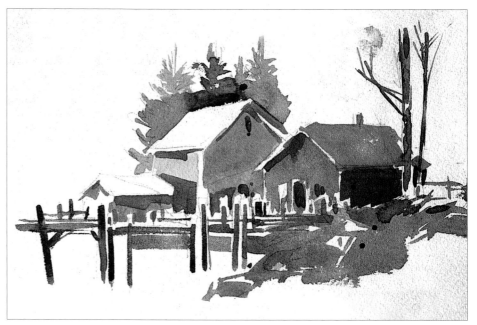

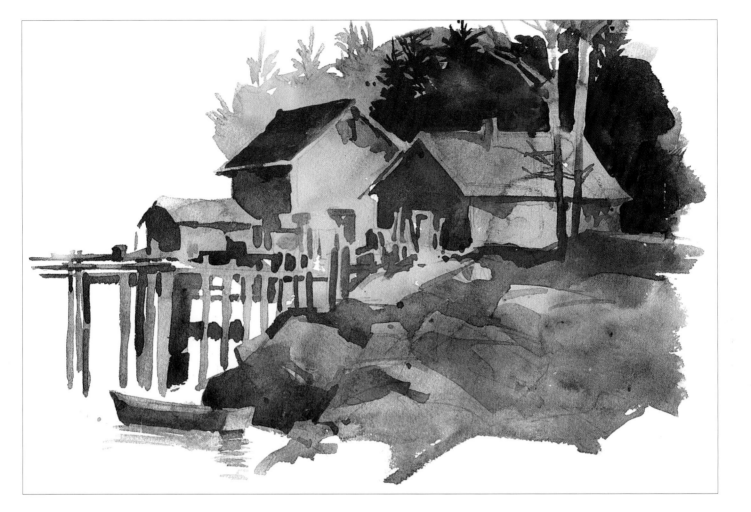

Workshop Experience

"I can't say it enough: Take chances! Break the rules! Who cares if one side of the boat is green and the other is blue and yellow? It looks fresh, alive, bright and artistic, and that's what you want in a painting."

Workshop Experience

"Painting loosely in wet and wild colors takes some practice. Here's one of my workshop lesson charts encouraging you to mix up some color in your palette and experiment with putting it on the paper in any random pattern. Don't paint objects at first. Just focus on learning to make color changes every few inches, overlap colors and keep the amount of water consistent to avoid causing

watermarks or backruns. Once you've got that down, apply the same approach to painting an object."

On Location: Color Sketches

Pass up the pencil and experiment with color!

Here's a 45-minute exercise to get you thinking and painting with bright, exciting, varied color.

Pick a scene, and set up your paints and brushes next to your 8 x 10" sketchbook. Now, skip the pencil sketch and just start painting in color! Pencil lines can be too confining, influencing you to be too mechanical with your brushstrokes and color choices. This exercise is meant to set you free.

As you paint, try to:
- Keep the colors light and bright.
- Go beyond the actual colors you see.
- Achieve a variety of colors, textures, edges and strokes.
- Focus on using color to express feeling and character.
- Stop when you've captured an impression of the subject.

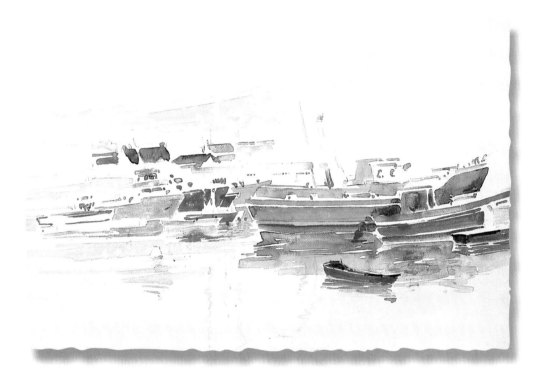

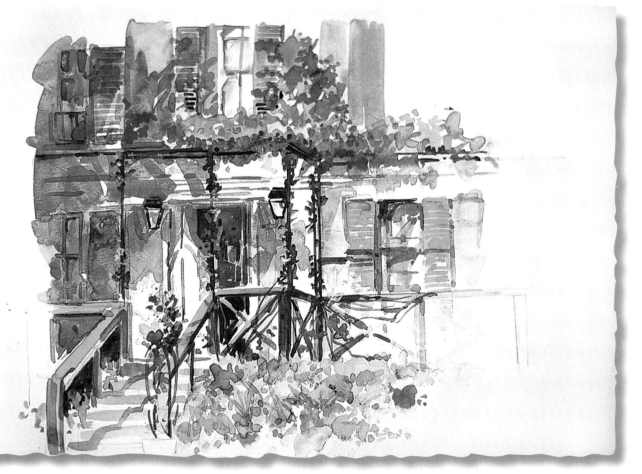

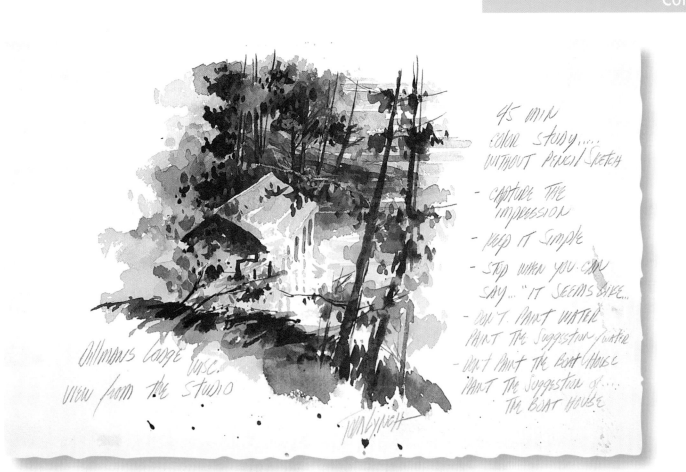

45 MIN
COLOR STUDY....
WITHOUT PENCIL SKETCH

- CAPTURE THE
 IMPRESSION
- KEEP IT SIMPLE
- STOP WHEN YOU CAN
 SAY... "IT SEEMS LIKE...
- DON'T PAINT WATER
 PAINT THE SUGGESTION / WATER
- DON'T PAINT THE BOAT HOUSE
 PAINT THE SUGGESTION OF....
 THE BOAT HOUSE

Allman's Lodge Wisc.
View from the STUDIO

8 x 10" sketch

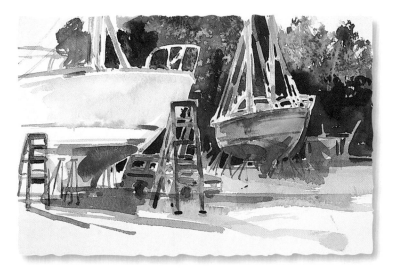

Traveling Light

"For a watercolorist, painting on location requires a little organization. I recommend packing all of your painting gear in a lightweight backpack. Make sure it's large enough to hold your four or five favorite brushes, paints, a palette, a container for water, a supply of watercolor paper, a sketchbook and a few other assorted tools and equipment. One last item that I'd encourage any artist to buy is a folding stool, like the one I'm sitting on here. You'll thank me for this last recommendation someday."

55

Using Color as a Salvage Technique

Next time you reach for the same old color, think twice.

There's nothing wrong with painting a familiar subject that you, or other artists, have painted before. But why paint it the same old way? If you let your paintings explode with a variety of colors, your work is guaranteed to be different! Next time you're in the studio, be bold with color and make your rendition of whatever subject you've chosen unique, exciting, lively, special.

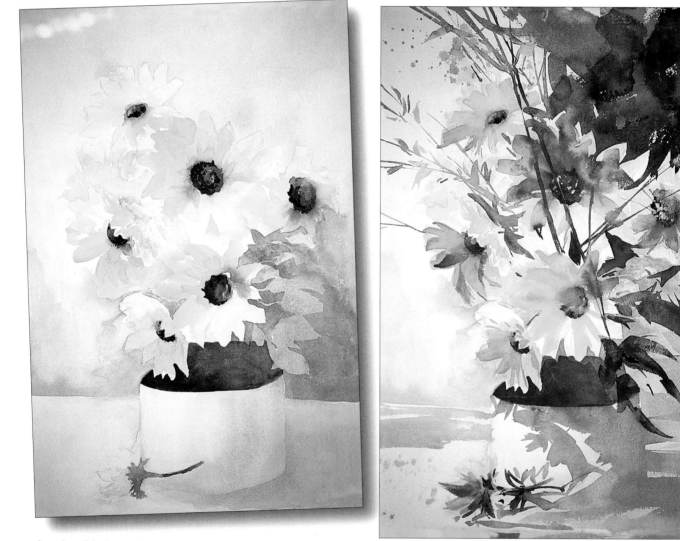

Lack of interest
A subject that has the same color throughout quickly becomes repetitive and boring.

In my revision, I used a little artistic creativity to make each flower slightly different and unique. Now the viewer has something new to look at in every inch of the painting.

"I call the brightest colors on my palette my 'juice colors' because I can use them in my impact area in their pure form or mix them with other colors to brighten up similar hues in non-impact areas."

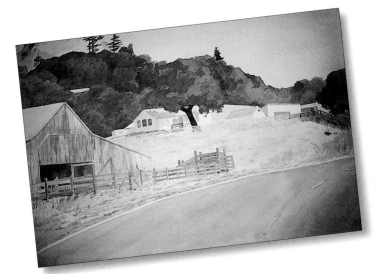

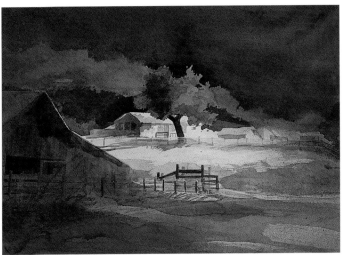

Predictable color
Painting nature doesn't mean limiting yourself to natural or "earth" colors.

Look at how much more exciting this painting is when done in vibrant yellows and rich blues and purples.

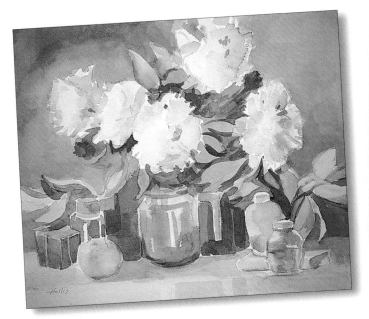

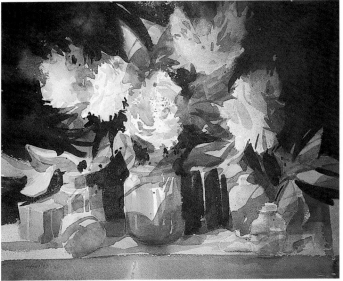

Lack of contrast
Contrast equals excitement. Lack of contrast is the complete opposite.

In re-working this painting, I used some of my juice colors on the left, as well as some of my favorite shadow colors on the right, to spice things up with contrast.

Showcasing Color

As you can see, I like to rev up my paintings with bright, rich colors.

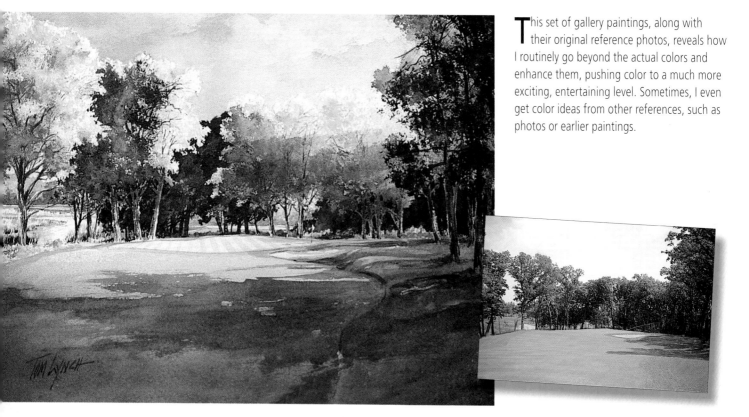

This set of gallery paintings, along with their original reference photos, reveals how I routinely go beyond the actual colors and enhance them, pushing color to a much more exciting, entertaining level. Sometimes, I even get color ideas from other references, such as photos or earlier paintings.

Opting for color variety precludes boredom
All green = sameness = boring. To rev up **"Stonewall Orchard" (22 x 30")**, I included lots of other colors besides the greens, such as yellow, violet, magenta and blue. Some of these aren't your typical "tree" colors, but does it matter? They make the painting lively.

From dull to dazzling!
Compare the original photo and the final painting of **"Riverwalk"(22 x 30")**. You'll find that I used essentially the same colors as in the reference photo, only my versions of each of those colors is purer, cleaner and brighter.

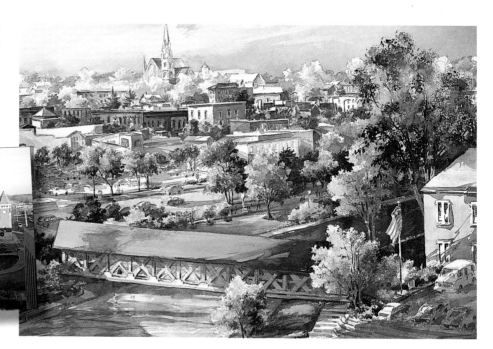

A good example of how rich mixes are more exciting
Even a night scene, such as **"La Cité d'Amour" (22 x 30")**, needs a lot of
color. Look closely at those darks to see the rich mixes of Royal Blue,
Ultramarine Blue Deep, Permanent Magenta, Hookers Green and Burnt Sienna.
I was inspired to use these colors by a photograph of a different sunset.

"If you vary the colors, tones and values to
a much greater extent, the painting will grab
the attention. To me, this is the difference
between painting and making pictures."

Shapes

Good shapes are the foundation for a successful painting. Let's have some fun with them.

I have this theory. The more "real" you try to paint something, the more your viewer will focus on the facts, such as the type, the kind, the place. But does it really matter if it's a Fuji apple or a Red Delicious in your still life? Of course not. Painting isn't about who, what, or where; it's about impressions, suggestions, entertainment and mood.

One foolproof way to make your paintings look less real, and more inviting, is to play with the shapes in your subject. Used effectively, shapes can be altered and arranged into an expressive painting that will allow your viewers to sit back and enjoy the way it makes them feel.

Below: **"Red Rock Crossing" (22 x 30")** Right: **"Arc de Triomphe" (30 x 22")**

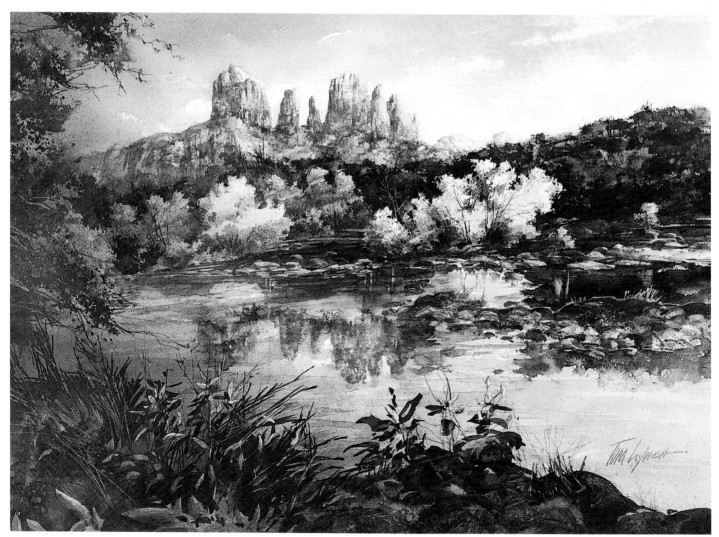

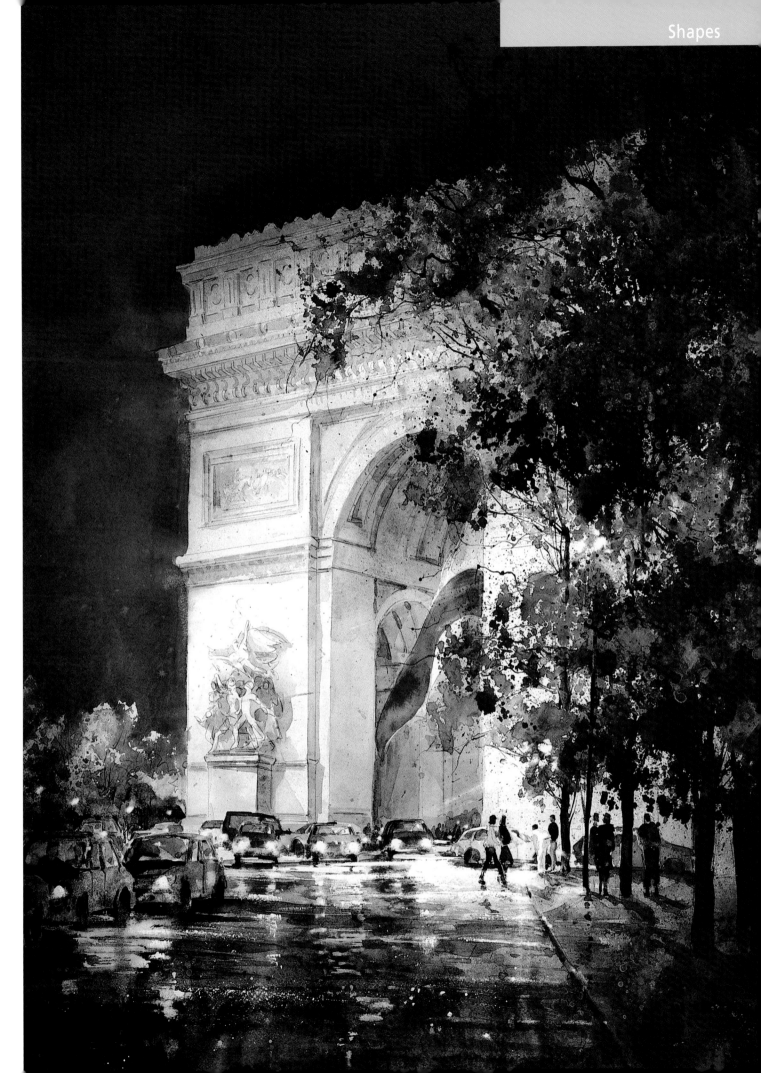

Understanding the idea of designing with Shapes

Here's where I'll show you how to turn random shapes into a well-designed painting.

When I'm starting a new painting, shapes are the first thing I think about. And when I'm asked to judge paintings for a show, an eye-catching design or arrangement of shapes is the first thing I look for in each work of art. Good shapes are the foundation of successful paintings.

How do you learn to turn random shapes into well-designed paintings? One of my teachers once told me to find a good book on design, read it twice and throw it away — the things I remembered would be enough. Well, I'm not sure if that was helpful or not, but I have developed a simple theory on design that you can use. First, look at the individual objects,

as well as the background, in your subject to determine what general shapes they conform to. Think only in terms of shapes, not things or objects. You need to know if you've got a circle, square, rectangle, triangle or a straight line in your drawing because if you do, you're going to have to do something to alter those shapes. You'll also want to avoid symmetry and repetition as they, too, make for boring paintings.

If you discover you have a bad shape in your subject, you have several options for changing it. You can 1. alter the shape (even a somewhat awkward shape is better than a perfectly geometric shape), 2. overlap or combine two shapes together into a new, more interesting

unit, 3. cut out or obscure the bad shape, or 4. stylize or abstract the shape.

Next, look at all of the shapes as a whole. You want to make sure you have a variety of sizes of shapes in your overall design. In fact, my design teacher, Ed Whitney, taught me a great saying I'll never forget: "When designing, think of the three bears — papa (large), mama (medium) and baby (small)". It's the easiest way I can think of to remember to put at least one of each size in your designs.

Don't be afraid to change the shapes found in your reference photos if it's going to improve the design. Look at "Monet's Walk" shown here, for example. In the original reference

Combining references
The shapes in the original reference for **"Monet's Walk" (50 x 30")** were nearly equal in size, so I brought in some azaleas from another photo reference to improve the design of the shapes in the final painting.

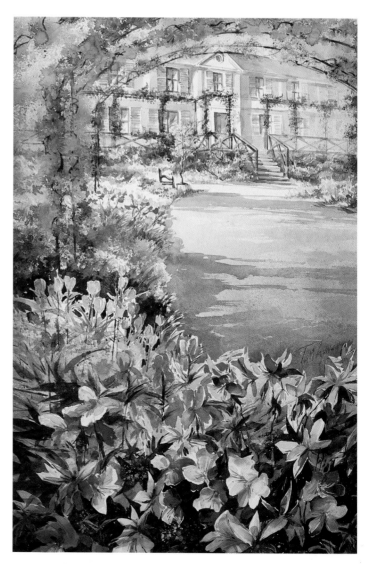

photo, the shape of the overhanging arbor, the shape of the flower bed and the shape of the walkway were almost equal in size. Sorry, Claude, but I needed a design change — I had to alter at least one of these shapes to create a mama, a papa and a baby. I accomplished these changes by cropping out some of the arbor and by enlarging the flower bed across the foreground. The addition of a mass of other spring flowers also broke up the repetitive boredom of the tulips and eliminated the straight line along the edge of the path.

Remember, your viewers want to enjoy your creativity and escape the real world for a moment through your art, so don't make your paintings completely accurate and realistic. If the shapes in your photo or sketch are bad, don't follow them. Enhance your paintings by making your shapes and their arrangements more satisfying and interesting than what you'd find in real life. Vary the sizes (mama, papa, baby), vary the spaces between shapes and eliminate any perfectly geometric shapes or straight lines. Your viewers will let go of any predisposition, expectation or analysis, and simply appreciate the story you've got to tell.

These static shapes can be improved

Here are four better ways to do it

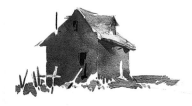

Alter the shape slightly

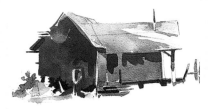

Connect the shape with another

Shape Checklist

- *Look at the subject and determine the general shapes.*
- *Think in terms of shape, not object.*
- *Avoid symmetry and repetition and you'll avoid boring.*
- *Change any bad shapes.*
- *Evaluate the size of your shapes. Make sure you have variety. Think of Edgar Whitney's "Three Bears".*
- *Avoid making everything realistic and predictable.*
- *Vary sizes, spaces and eliminate perfect geometry and straight lines.*

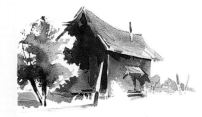

Camouflage the shape behind something

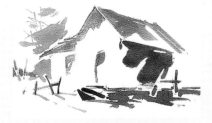

Abstract or stylize the shape

Workshop Experience

"Exact repetition and symmetry detract from the design of your paintings. So if you've got a circle, square, triangle, rectangle or straight line in your subject, adjust it. To improve a shape, try altering, overlapping, obscuring or stylizing it, as these examples demonstrate."

How to make Shapes work for you

In this demonstration, I'll show you how I set out to create a loose, dynamic painting by playing down the subject and focusing on making knock-out shapes.

No matter the subject or purpose of the painting, a good design of shapes, including a variety of sizes, is essential. But for me, working with dynamic shapes is so interesting that I sometimes let them be the primary focus of the painting. For example, this demonstration is simply about having fun with shapes by stylizing and abstracting them. Although it looks different than many of my other paintings, I feel that the ability to paint in a variety of styles is what makes a skillful painter.

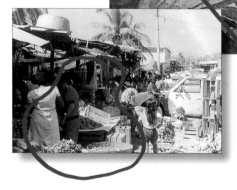

Composing from photos
When I developed this subject, I pulled ideas from three different photographs, using a black marker to highlight the different sections I wanted to feature. I adopted the figures from the background of one photo and the two sheds, along with the boxes and produce from the other two pictures.

Laying the first wash

I wanted this painting to be loose and dynamic, so in my first wash, I left lots of white paper that could be covered later. I also used a variety of colors, all in the same value, so that I could focus on the pattern of shapes. Notice how I stylized many of the shapes by linking some and cutting into others to create more interesting shape units. No two are alike, and none are perfectly geometric.

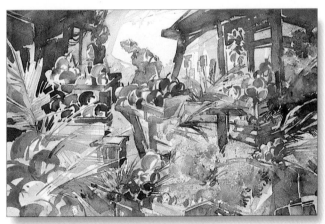

Refining the shapes

In this stage, I added a suggestion of background. I played the game of values — light against dark, dark against light — to add interest to the shapes. At this point, I've achieved my goal of painting with stylized shapes so the painting could be considered complete, but I continued looking for ways to give it more impact.

Bringing out the center of interest
To make the impact area in the center stand out more, I darkened and unified the outer edges by spraying them with a fine mist of color from a small pump-spray bottle. I chose Cobalt Blue, a cool color, to work as a foil against the warm colors in the impact area.

Weighing my options
"Market Patterns" (15 x 22") could now be considered finished. But before calling it complete, I experimented with a few possible shape additions on an acetate overlay (see opposite page). Since these didn't really contribute to the overall design, I decided not to make the changes on the actual painting.

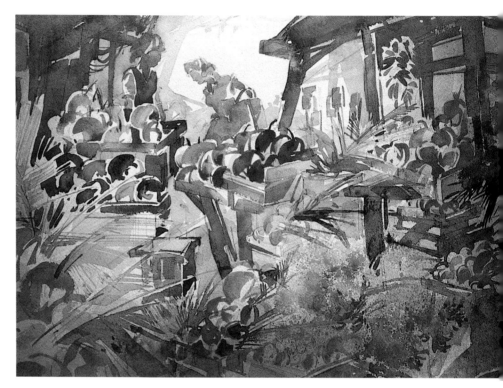

Workshop Experience

"After laying in your first wash, put both a light mat and a dark mat over your painting to help you focus in on the work-in-progress. In addition to showing whether your values are correct and your colors clean and fresh, this gives you the chance to look at your shapes. Pausing for a moment will help you decide what smaller shapes — in which locations, values and colors — to add in your second application. Interestingly, you'll save yourself about 45 minutes' worth of work because the mats will show that you need fewer refinements and have less work to do before the painting is finished."

Test your ideas with an acetate overlay

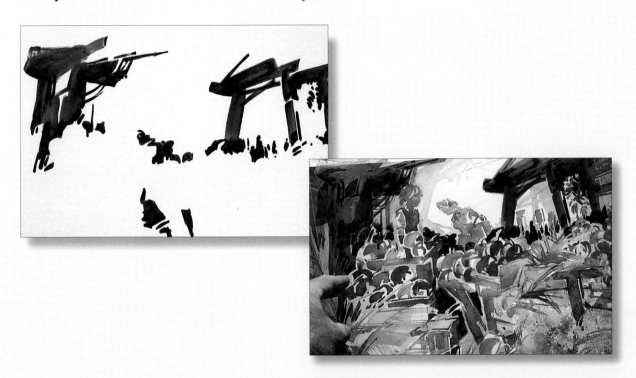

"I always encourage my students to be bold and take chances, but there will be times when you've got a painting that's looking good and you don't want to blow it by making a change that might not work and can't be undone. When this happens to you, use this great tool for trying out potential changes without actually making them on your painting surface — it's called wet-media acetate. This clear plastic surface has been treated to accept and hold a watercolor wash. To use it, simply lay the acetate over your painting, as I'm doing in these examples, and make the changes on the plastic. If your ideas take the painting to a new level of impact, then you can apply them permanently. If not, your painting is still intact."

On Location: Shape sketches

You can pick and choose shapes from a variety of viewpoints.

If you need to practice combining shapes from different scenes into a great design, try this experiment. Remember, your objective is to create artistic results, not report exactly how the scene looked.

With your sketchbook in hand, find a location that offers good views all around you. Study the scene immediately in front of you, then turn a quarter turn and study that scene, and repeat until you've looked in all four directions. Now decide which of the four viewpoints offers the best shapes in the foreground and draw or paint those shapes on your paper. Next, choose the viewpoint with the best middle ground shapes and draw those, and repeat this step for the background. This same exercise can be done by choosing one viewpoint for the shapes on the left side of your sketch and another viewpoint for the shapes on the right. Just remember to pick the viewpoints that will provide an overall variety of sizes in the shapes — think mama, papa, baby.

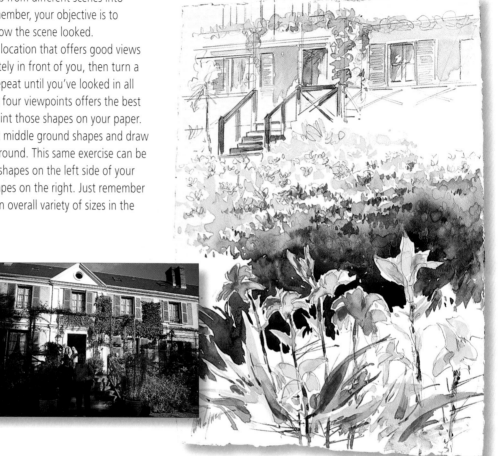

Pulling shapes from two views
Originally, this view of Monet's home had only a series of small shapes in the house and one big shadow shape. Notice how, in my sketch, I used medium-sized flowers from another viewpoint to break up that big shape.

Workshop Experience

"When I'm looking around for a new subject to paint, I always look for a variety of sizes, angles, shadow groupings and spaces between the shapes. It's unusual to find all of these requirements in one photo reference. Quite often, I need as many as three separate photos to provide the shapes for the foreground, middle ground and background.

Once I've worked out the design and started on the painting, I don't refer to the photos anymore. I try to make my paintings more entertaining for my viewers by altering, stylizing or abstracting the shapes and exaggerating the colors, values and contrasts."

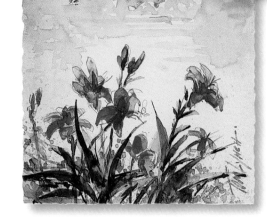

There's always room for improvement

Again, my original view of Monet's Japanese bridge offered shapes of roughly the same size. To add more variety in my first sketch, I incorporated some nearby flowers. Then I took that one step further in my second sketch by including a small boat. Making a preliminary sketch allowed me to work out my design and get a good visual idea of where to go in my studio painting.

Workshop Experience

"Good design is all about variety. Start by making your positive and negative shapes more varied and dynamic. In other words, avoid perfect geometric shapes, straight lines and even edges. Then check the sizes of your shapes to ensure variety in this respect, too. Whatever you do, don't copy your scene or subject exactly if it has boring, repetitive shapes. Use your creativity to make the shapes and the design more interesting."

Using Shape as a Salvage Technique

Very often a painting looks wrong because the artist hasn't paid attention to shape. Here's how to spot the mistakes and fix up those paintings.

As an artist, you always have the option of altering, removing and rearranging the shapes in your subject to enhance the design. Just look at how these three paintings were improved by some shape adjustments and additions.

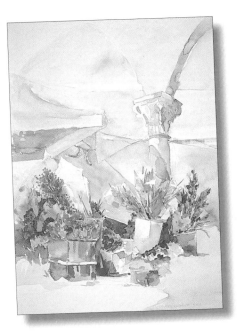

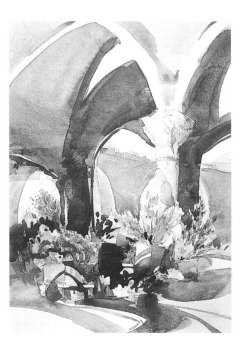

Uniform shapes need a shake up
Where are the mama, papa and baby shapes in this original?

By creating big, sweeping arches as a foil for all of those small clusters and objects, I put more variety in the sizes of the shapes.

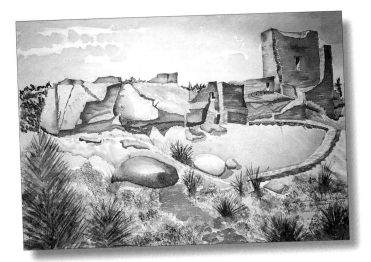

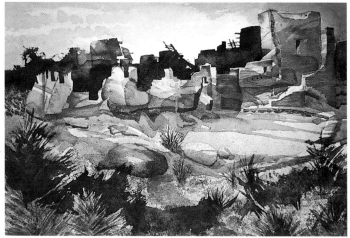

Too many straight lines, squares and circles
The original scene may have looked this way, but that's no excuse for making the painting look bad or boring.

In my revised version, I've still captured the flavor of the old Indian ruins, but without displaying a static image. To improve things, I obscured the straight line and square shapes of the village and eliminated the dinosaur egg (circle) in the center.

"If you discover you have a bad shape in your subject, you have several options for changing it."

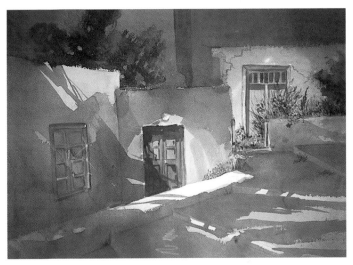

Shapes too similar
A subject with a static design presents a challenge.

Here, I created the illusion of different sizes of shapes by casting shadows, leaving irregular shapes of light. This prevents the viewer from being bored by the similarly sized shapes.

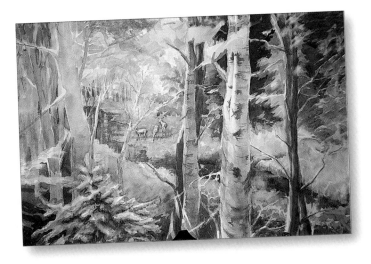

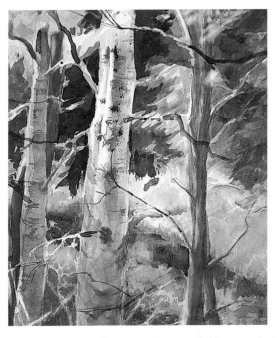

Too much information
Sometimes the best way to improve a painting with too many shapes is to crop it into a new format.

I felt the dominant foreground trees called for a vertical format, which I created by ripping the painting in half. (You should have seen the look on my students' faces!) To ease the pain, I salvaged both halves. In this half, I used additional dark shapes to underscore the height of the trees.

Showcasing Shape

Here's a round-up of shape ideas you can include when you're designing and refining your own paintings.

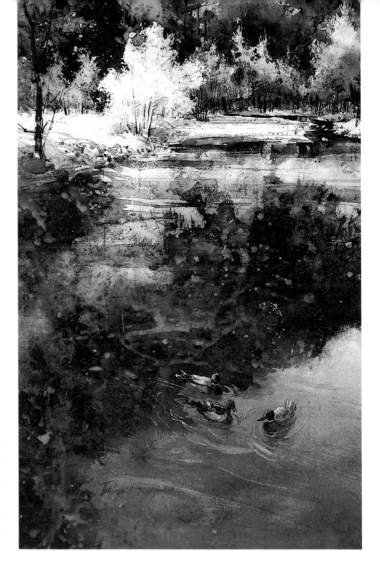

Quite often, I find my reference photos don't have enough shape variety, but I don't draw from my imagination to find solutions. Nature itself provides more and better options, so I pull ideas from my collection of additional reference photos and sketches, looking for interesting shapes, angles, sizes and spaces.

Distinct separation of shapes added pizzazz to this one
When painting **"Yosemite" (21 x 15")**, I placed the horizon line high on the paper. This turned the river and embankment into one large shape, distinguishing it from the medium-sized shape of the middle ground meadow and the smaller shape of the background trees. Note the dynamic shape of each tree grouping.

A good example of choosing unusual angles and breaking up shapes
Sometimes shapes can't be stylized or abstracted to make them more interesting. For example, I had to work with these buildings in **"Sunday in the City" (22 x 30")** just as they were. To make the painting interesting, though, I chose an unusual angle or viewpoint. Then I made some creative additions of organic tree shapes to break up the geometric building shapes.

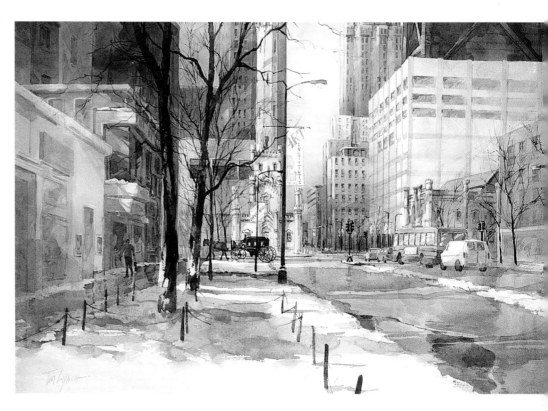

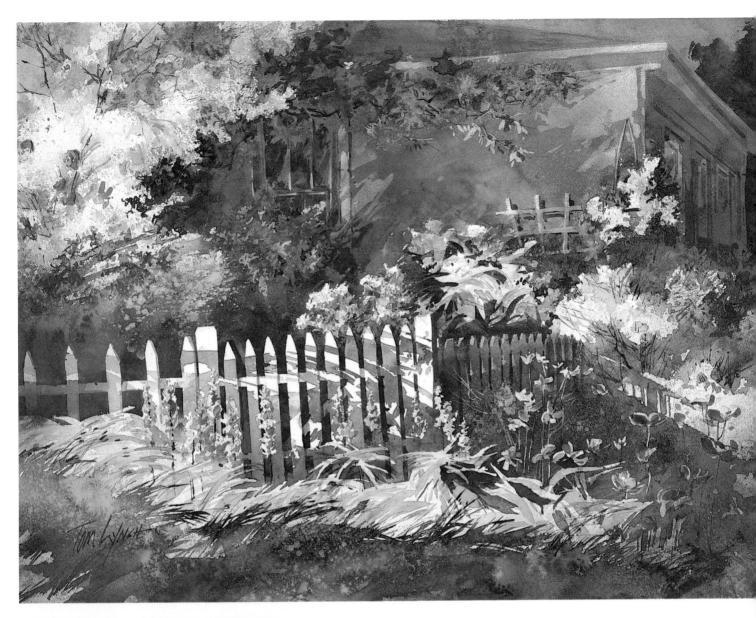

Thinking in shapes was the secret to this good design

Instead of thinking of my scene or subject as "things", I think of them as shapes. In **"Cape Cod Fence" (22 x 30")**, the house is a shape, the clusters of trees and bushes are shapes, even the portion of the fence receding in the shadows becomes its own separate shape from the fence in sunlight. Learning to see the subject as a series of shapes instead of objects helps me figure out how to improve the design more quickly.

Never forget that shadows can be great design elements

Look at the way the notched shadow cast by this flower trellis in **"Trellis Shadows" (22 x 15")** breaks up the foreground into a complex, intriguing pattern.

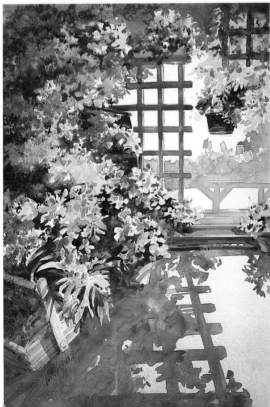

> ## "Painting isn't about who, what or where — it's about impressions, suggestions, entertainment and mood."

Impact Area

Give your viewers direction by showing them what's important — the impact area.

Viewing a painting is like taking a journey. You need a place to start, a place to rest along the way and a place to arrive. In a painting, the "impact area" or "area of emphasis" should provide all three. If it's done right, an impact area will grab your attention and give you a place to start. Your eye may wander off to other parts of the painting, but then you'll come back to the impact area to rest before exploring another part of the painting. Finally, after you've seen it all, you'll come back to the impact area to give one final review of the activity there. In other words, the impact area is like a roadmap, giving you direction as you journey through a painting.

Below: **"Amen Corner" (22 x 30")** Right: **"Paris Glow" (22 x 15")**

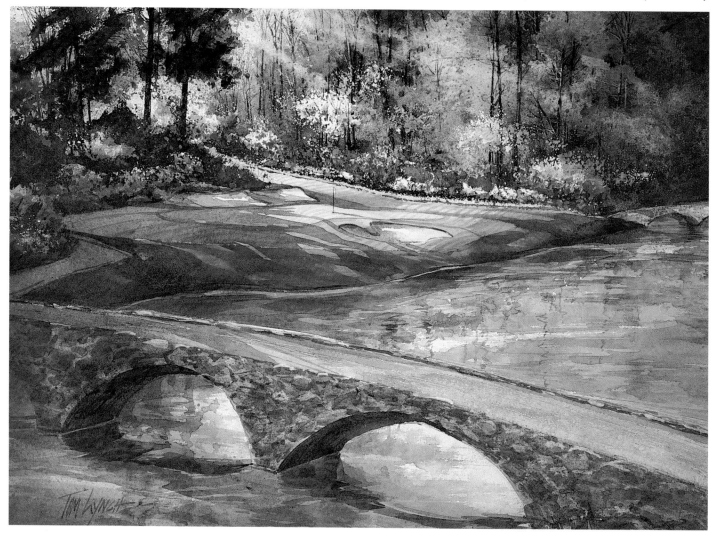

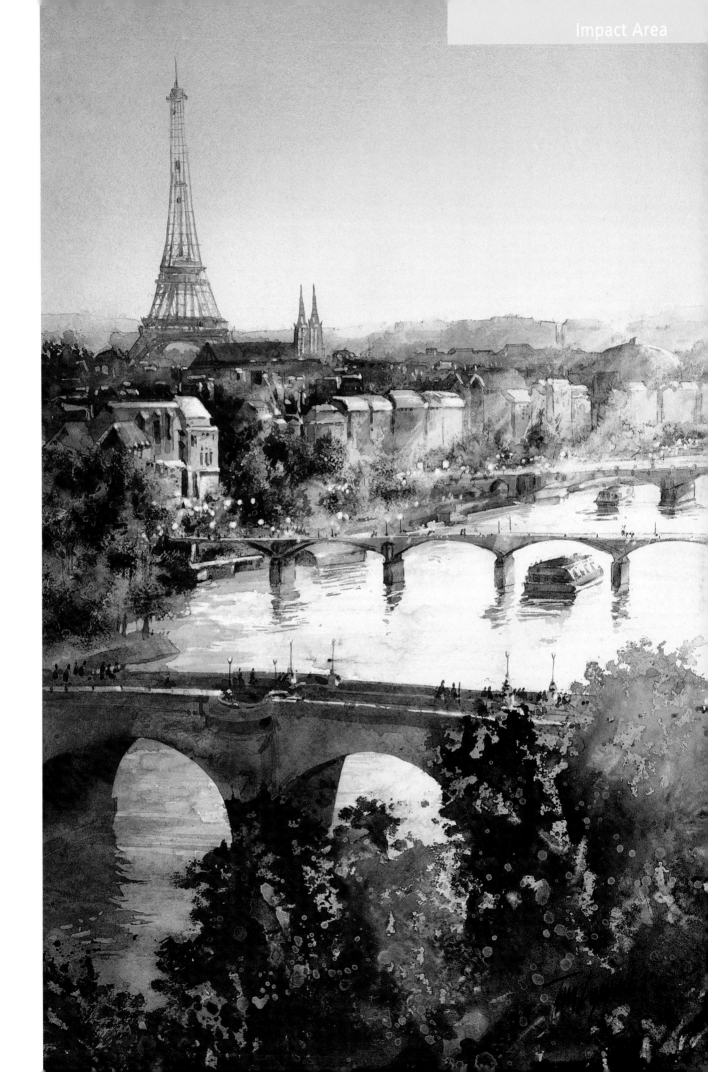

Defining the Impact Area

You've got 5 mighty tools to help you present a powerful impact area.
Let's take a look at your options.

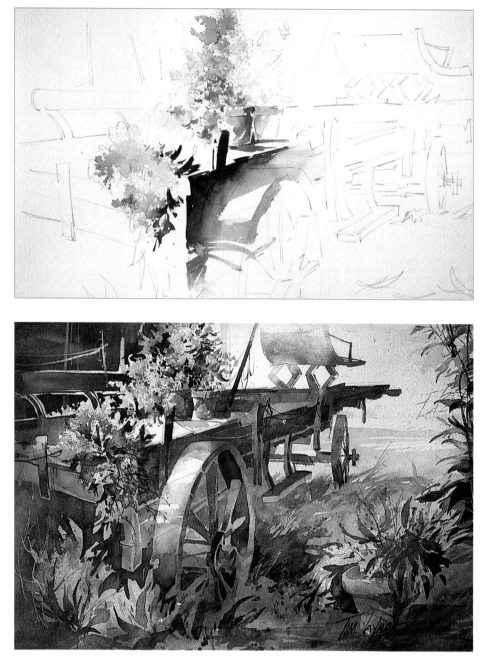

Off to a colorful start
Most of **"Ana's Wagon" (15 x 22")**, except for the sky and background, started as a rich, colorful first wash that continued from the impact area into the rest of the painting. Then, in later applications of paint on this workshop demonstration, I used color and contrast to draw attention to the impact area.

There's an artform out there in which no one area is more exciting than another and all parts are equally important. It has equal amounts of color, contrast, edges and detail throughout. This artform is called "wallpaper", and it's something I don't aim to create when I'm painting!

Instead, I want to create images that offer my viewers something powerful to look at and direct their eyes right to it. Some artists call this something the "focal point" or "center of interest", but this area shouldn't be a small "point" and it shouldn't be in the center. I prefer to use the terms "impact area" or "area of emphasis" because they're more accurate. Simply put, it's an area that attracts the eye.

Having an area of emphasis is essential — it's another thing that separates a painting from a picture. A picture has detail and well-defined parts throughout. But a painting should have areas that are prioritized, causing your eye to look at one area first before all others. This mimics the natural way we see the world around us. When we look at an object, that object is clear, in sharper focus with more detail, while our peripheral vision gradually softens everything else around it. In my mind, a painting that presents a scene in this way is far more engaging.

Now, as you can see by studying these studio paintings and the close-ups of just the impact areas, you have several options for emphasizing the most important area — through color, contrast, edges, detail and shape.

1 Bright color (including "juice colors", see Chapter Three: Color), strong contrasts of color, an unusual color reserved for one spot, or a color with a different temperature, will draw attention to the impact area.
2 Value contrast always grabs the attention — especially a super-dark against white paper.
3 Edges also draw the attention, so place your sharpest edges in the impact area and create softer edges around it. You can also

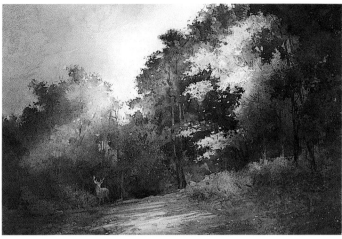

Dare to be different

In **"Falling Leaves" (22 x 30")**, I chose an unassuming part of a tree, falling leaves and a patch of sunlight on the ground for my impact area. Knowing that this was an unlikely selection, I had to give this tree a dynamic shape and keep all other tree shapes more vague. Then I used the brightest Permanent Yellow Lemon only in this area and its complement in the dark background. All of these elements — isolated color, hard edges, intricate shapes, strong contrast, complementary colors — contribute to making the area of emphasis stand out.

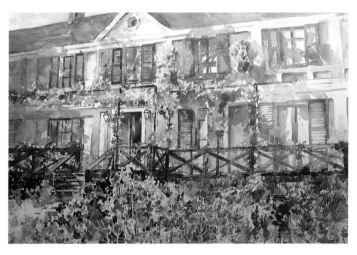

Carrying the mood throughout the painting

On location in Giverny at Claude Monet's home, I created a sketch that had far more impact than the 20 photographs I took. It had a colorful, delicate touch, and became my guide for keeping most of the studio painting more simplistic (or impressionistic). One final touch that I added to **"Monet Colors" (15 x 22")** was a fine spray mist of Cobalt Blue to the four edges of the painting. This subdued the whites, colors, contrast and detail in these less-important areas, thus enhancing the white paper, color contrast and edges in the impact area.

soften the edges outside the impact area by spraying a fine mist of color along the outer regions as a final step in the painting process.

4 The look of detail also makes a viewer notice the impact area, so I often use smaller brushstrokes, dots and dashes here. They don't have to be specific — just something to give the impact area a "busier" look.

5 Directional patterns or shapes are another useful way to guide your viewer to the impact area. The patterns, lines, edges and shapes of the "supporting characters" can be arranged to point or direct the eye toward "the star". For example, a river or road is a shape that can pull your eye from the foreground right into the impact area. But be careful with this technique. Directional shapes can be overused, creating a repetitive, static, artificial look, especially when you see all of your works displayed in a group.

A few other tips: Your impact area should contain pieces of several shapes or elements in your subject, not just one object. Don't pick the most obvious group of objects, but rather something unusual or unlikely. And finally, remember to keep the total area small, about 1/16th of the image size. Too large an area of emphasis will cause "eye overload".

Locating your Impact Area

My grid will help you visualize the best possible location.

The position, or location, of your area of emphasis is very important. You don't want it to be too close to the edge of the painting or the viewer's eye will travel right out. And placing the impact area in the center usually looks symmetrical or static, although occasionally it works. In general, there are four "safe" regions which are especially eye-pleasing locations for the impact area. I've developed a grid to help you visualize these regions and then place your impact area in one of the best possible locations.

I began by dividing a rectangle into 16 equal squares, then drew a circle in the center. Then I re-drew the four internal zones (minus the center circle) slightly larger. These four regions are handy starting points for locating your area of emphasis, giving you plenty of leeway in positioning it higher or lower, closer to the center or farther out. Trust your instincts to decide what looks best, but try to stay in one of the four regions.

Impact Checklist

- *Bright color*
- *Color change*
- *Value contrast*
- *Sharp edges*
- *Look of detail*
- *Directional shapes*

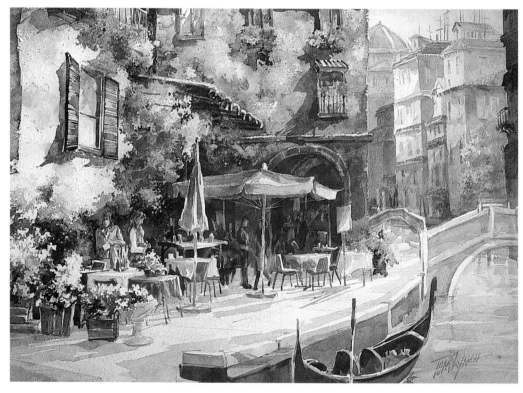

The impact tools in action
With all of the complexity in this scene, I needed to be very sure of the placement of my impact area before getting started. Then I used an isolated color, higher contrast, crisper edges and more detail to emphasize the impact area in **"Pessetti's Place" (22 x 30")**.

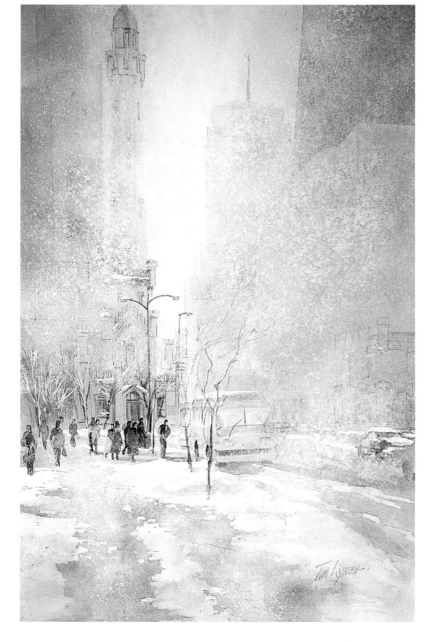

Never compromise on an impact area

When putting in the snow in **"Windy Bus Stop" (22 x 15")**, I went further than I needed to because I decided the feeling or mood in the painting was more important than layers, colors and edges. But what I didn't compromise on was having a clear area of emphasis in a good location. Note how my grid works on verticals as well as horizontals.

Workshop Experience

"Be bold when painting the impact area. It's much easier to subdue the impact area by glazing over a bright color, toning down a contrast of white or lifting a too-dark dark, than it is to try to strengthen it by painting over it again and again. Remember, start with a strong area of emphasis and constantly compare it to the rest of the painting, with an eye toward keeping the strongest impact where it belongs."

How to make Impact Areas work for you

Here's an orderly way of dealing with the impact tools.

As you'll see in this demonstration, I almost always start with the impact area. In fact, in about 75 per cent of my paintings, I decide how much color, contrast, edge work and detail to use to emphasize this area first. Establishing this area up front gives me a sense of direction — from then on, the impact area tells me what other colors, edges, values, shapes and so on, are going to support it and not distract from it. And, just as Ed Whitney taught me to do, I compare all additional brush marks to the impact area to see if my choices are working.

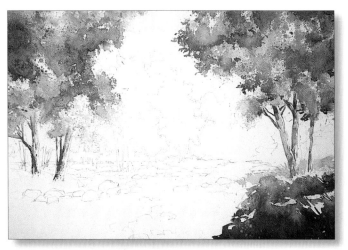

Pre-planning for impact
Before I put a single brushstroke on the paper, I decided where to place my impact area. I chose a small area on the left that encompassed part of one tree and some of the grass, rocks and water because the different elements made it interesting. Then I masked off some of the highlights in this area with liquid frisket to preserve the whites. After splattering in some bright light yellows around the impact area, I put in a gradation of values on either side of the painting.

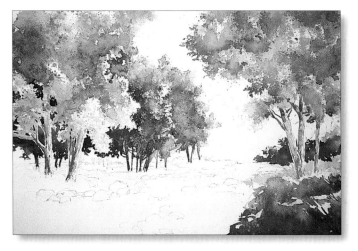

Going for contrast
Next, I put in some darker valued colors around the impact area, such as the rich blue-violet next to the yellow, so I could get a feel for the contrast I wanted to use here. I applied similar colors in a few other places for balance and unity.

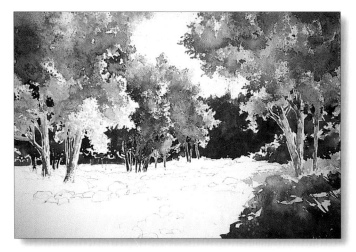

Layering for depth
To distinguish the farthest stand of trees from the trees in front of them, I had to choose a different value — either lighter or very dark. To help make the decision, I considered my impact area. Since this area was relying on light values and bright colors to make it stand out, I went with a very rich "super-dark" that wouldn't compete with the light values. However, I did add some texture to both areas to link them together in some way.

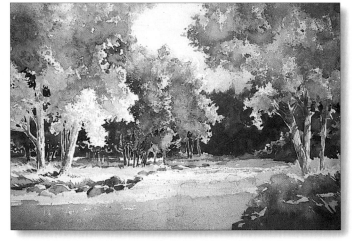

Mapping other values
With my other layers of value in place, I pretty much had to go with a light valued sky. Again, I used soft, pale colors so the sky wouldn't detract from the impact area's brighter light colors. I also let the impact area guide me when putting in the water — I made the color brighter and lighter along the bank and darker as the water moved into the foreground. In both the sky and water, I used a lot of purple to complement the yellows in the impact area.

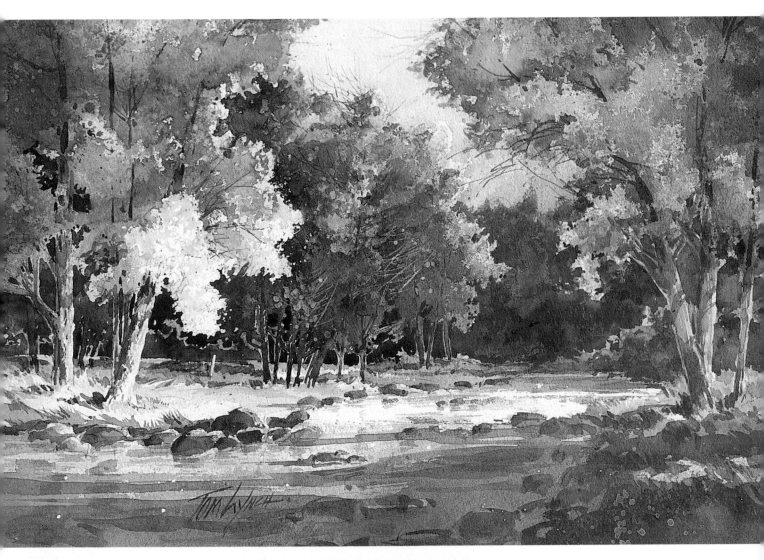

Drawing attention to the impact area

Once I had the entire surface covered, I removed the frisket and considered how to further enhance the impact area. I added both brighter, more vivid colors as well as some extra darks to make it pop. As I applied these colors, I used sharper edges, again for contrast. Just a few loosely applied details in the river and rocks finished **"Autumn Colors" (15 x 22")**.

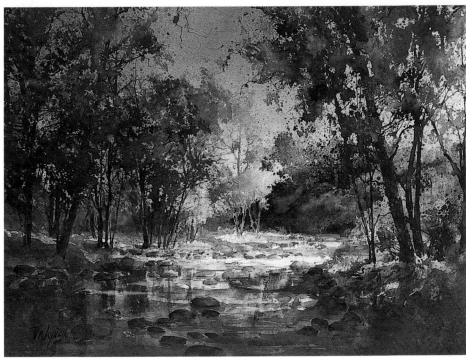

Same scene, different treatment

This is actually another version of the same subject called **"Autumn Light" (22 x 30")**. Comparing them like this just shows that the artist always has the power to place the impact area anywhere in any of the four preferred regions, no matter what's happening in the actual subject or scene.

On Location: Impact Sketches

Limit your thinking and you'll get dramatically different results.

Here's an exercise that will train you to strategically place and develop your impact area.

First, find a subject and think about which sections of intersecting shapes might make good impact areas. Choose the least obvious one, and draw a pencil sketch that positions it in one of the four best regions for locating an impact area. Draw the design grid on your sketchbook, right over your drawing, if that'll help you work out the design.

Next, paint just the impact area. Exaggerate the use of your brightest "juice" colors, contrasting values, crisper edges and some fine detail in this area. Now stop. Don't develop your painting any further. Study the effect — the impact — of this area so you can start to understand the power of a strong area of emphasis.

If you want to take this concept one step further in your next practice session, repeat the exercise using the same subject, but choose a different section to act as your impact area. Compare the two to see how emphasizing various areas can yield dramatically different results.

If you like, you can save these practice sketches and paint studio paintings from them at a later time. Keeping the sketch in front of you while you work will remind you where the impact area is located and how to emphasize it.

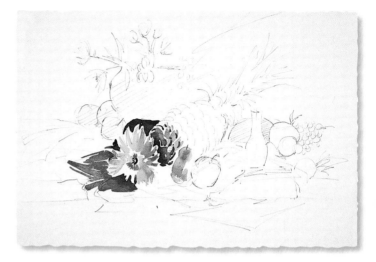

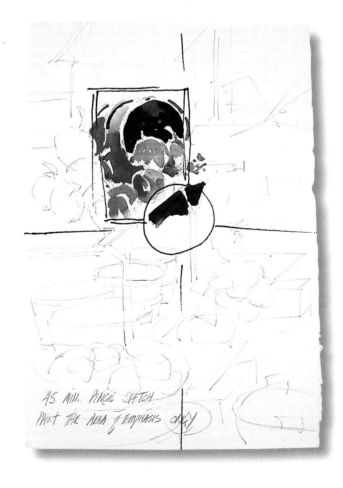

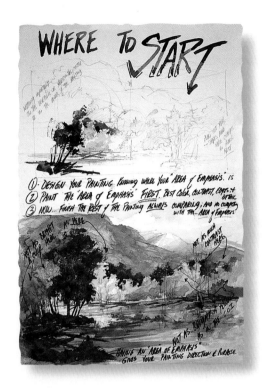

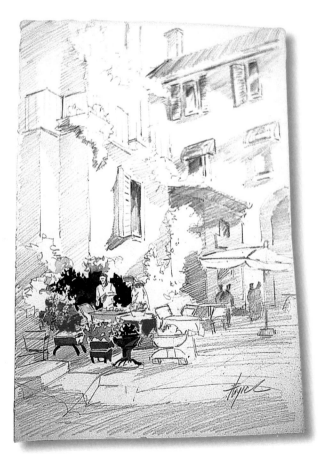

Workshop Experience

"Many artists have trouble getting started. My suggestion is to start with design sketches, placing your area of emphasis in one of the four regions of the design grid. When you're ready to go to work, paint the area of emphasis first, paying close attention to colors, contrasts, edges and detail. Think of the impact area as a separate painting-within-a-painting, and develop it accordingly. Then, as you work on the rest of the painting, always compare the secondary areas to the impact area, making sure it continues to be the brightest, most powerful, most interesting spot in the whole piece. With this approach, you'll be able to create paintings that have an unmistakable area of emphasis, as I did in 'Night Game' (22 x 30"), below."

Using Impact Areas as a Salvage Technique

By accentuating some areas, and playing down others, you can create a moody story instead of a literal copy.

As I judge art competitions and critique my students' work, I've realized that perhaps the number-one missing ingredient in most paintings is a strong impact area. It's either non-existent, too weak to be noticeable, too big, too obvious or located in the wrong place. Study these examples to see how much better a painting can be with a clear area of emphasis.

There's an impact area, but it's way too big
Obviously, this painting's main subject is the boats, but that's too large for an impact area — roughly half the painting.

Instead, I chose to focus in on a more reasonable area, deliberately choosing a small spot where several interesting shapes came together. Then I strengthened the color and contrast in this area, while darkening everything else, to make the area of emphasis stand out.

"The number-one missing ingredient in most paintings is a strong impact area. It's either non-existent, too weak to be noticeable, too big, too obvious or located in the wrong place."

One object and a little too obvious
This bell stands out because it's large and isolated. Unfortunately, these aren't the best ways to highlight an impact area, nor is this the best choice for an area of emphasis.

In my revision, I used rich purple-grays on the bell and the walls to tie them together, and applied a contrasting yellow — as well as a shadow detail and crisper edges — to create an impact area that included just a part of the bell and a part of the wall.

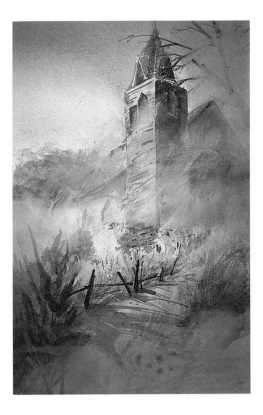

This one is a bit too literal
Here again, the whole church is too large and too obvious to function as an area of emphasis.

I let a small area involving part of the fence, the bush and the light on the ground become the impact area by lifting and softening many other parts of the painting. In turn, this created a foggy atmosphere that lends an air of mystery to the painting. Now the painting is telling a story rather than merely recording how the church looks.

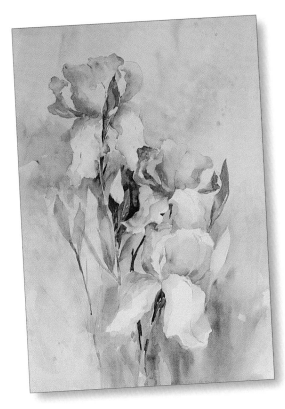

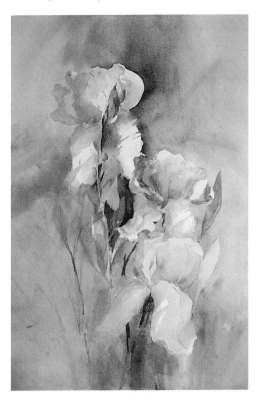

Repetition works against this one
If you're going to paint two or three of the same object, such as these flowers, you have to pick part of one of them to be the impact area.

I chose part of one flower and part of the background, and gave them stronger color, higher contrast and more emphasis to distinguish them from the other similar objects.

85

Showcasing Impact Areas

Here is a selection of studio paintings with strong impact areas.

In looking at the original reference photos, you can see they did not have built-in areas of emphasis. It was my job to select where and how to create this impact area. In some cases, I had to turn to additional photo materials for more information. Just because I'm an artist doesn't mean I have to rely on "divine inspiration".

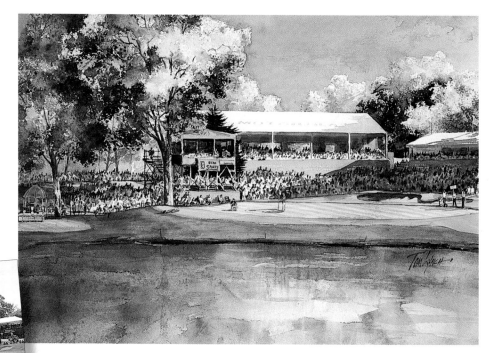

Going beyond the obvious

I'm asked by many tournaments and private golf clubs to paint specific events, but I'd rather have the viewer enjoy the beauty of the place than to record an exact moment in time. To do this, I bring the viewer's eye to an unlikely area first, such as the broadcast booth area in **"Final Putt" (22 x 30")**.

Let the viewer fill in the blanks

In **"Hinsdale Country Club" (22 x 30")**, I brought in flowers from another photo to add variety to my unusual area of emphasis. Interestingly, the golf course owner who commissioned this painting thinks I did a great job showcasing his course, even though I didn't show any golfing activity. What I really did was to showcase the beauty of the flower beds while adding a golf course behind them.

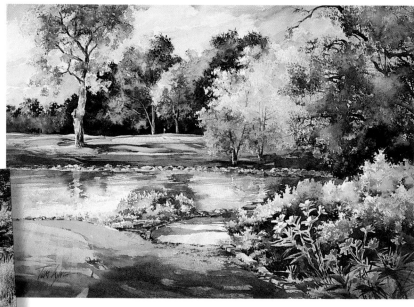

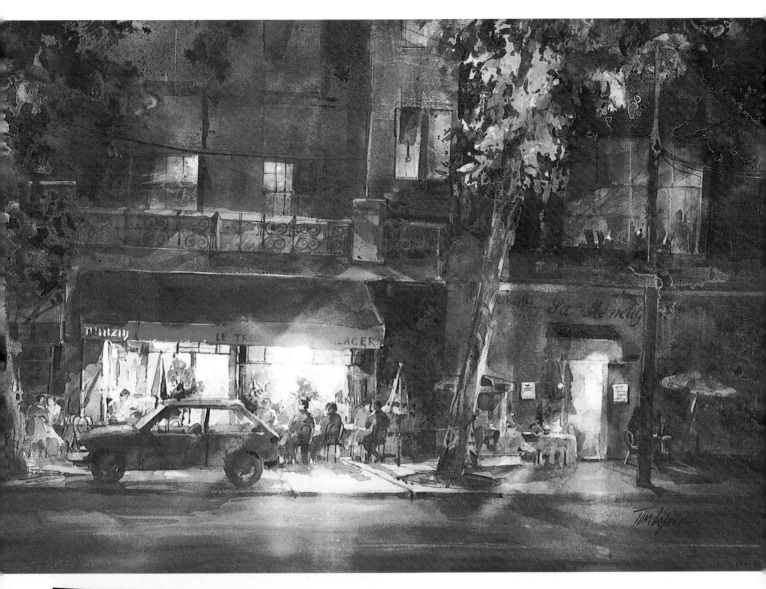

A smaller impact area holds more power

The original photo reference for **"Night Café" (22 x 30")** already had a strong area of emphasis, but it was too large, which put the responsibility on me to choose a smaller, more striking area of emphasis. Through sketches, I determined that the right window of the café would be a better place for the impact area.

Expression and Mood

The key to this whole concept is to pick no more than two feelings that you want to communicate, then exaggerate them!

Expression, mood, feeling — whichever term you prefer — I'm talking about the something "extra" that you experience when you first see a subject you want to paint. It's also the something "extra" you'll want to communicate through your artwork so your viewers experience the same sensations that inspired you. As with so many other concepts in painting, the key to getting that "extra" across is exaggeration — so much so that your mood or feeling can't be missed.

Below: **"Hot Light" (22 x 30")** Right: **"The Vatican" (22 x 15")**

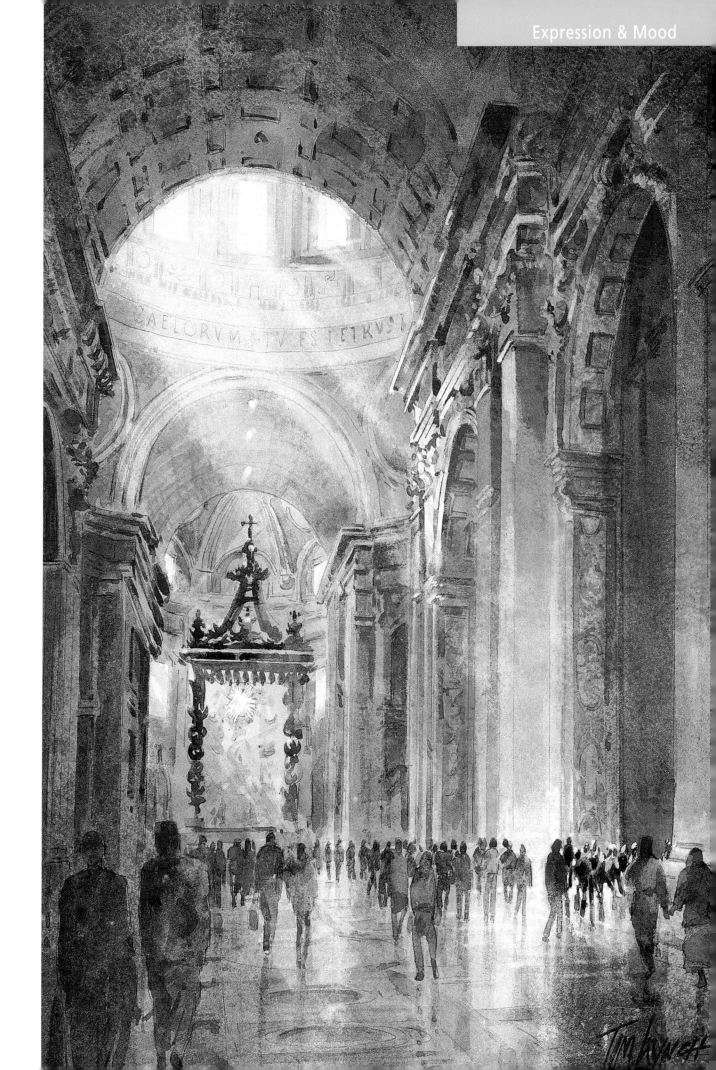

Putting it all together

Sometimes the Big 5 — technique, color, shape, value and impact area — should take a back seat to expression!

Make the mood obvious
I always try to exaggerate the feeling I'm trying to express. This may sound contradictory, but even when I'm going for a delicate look, I want it to be dramatically delicate. For example, I loved the soft light and simple elegance in this original sketch done near the Eiffel Tower, so I avoided a heavy-handed approach and concentrated on recreating those sensations in **"A Soft Touch" (22 x 30")**.

Once you've mastered the fundamentals of techniques, color, shapes, value and impact area, you need to learn to incorporate one last essential element into your art — expression. Actually, the fundamentals go hand-in-hand with expression because they allow the viewer to comfortably take in the mood. However, when the expression is meant to dominate, the fundamentals need to take a back seat.

First, let me explain what I mean by mood. A mood is an adjective that describes the feeling within the painting and the effect it has on the viewer. For example, words like soft, warm, bright, sparkling, colorful, bold, dramatic, cool or delicate all describe moods or feelings. On the other hand, a cabin in the mountains, a sunset or a table in a café are not moods — they're things. However, anything can have a mood, depending on how it's painted.

I think all paintings should have some degree of mood. Sometimes, you may even want the mood to be stronger and more important than the subject itself. The expression or feeling in a painting tells the viewer what you saw or felt about a particular

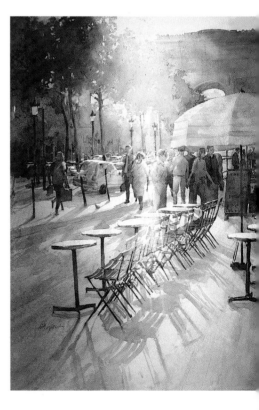

Weighing the options
Preliminary sketches are a great way to experiment with a mood and how to express it. For instance, my photo reference for **"Hot Street Patterns" (22 x 15")** brought back my memories of a very hot day, but I had to figure out how to get that idea across to my viewers. Through my preliminary sketch, I figured out how to exaggerate color and value to capture the heat of this sunny summer afternoon.

subject, the thing you found so intriguing that you wanted to paint it. If your painting can evoke the same emotional response in your viewer that you felt for your subject, then your viewer's imagination and soul will be stimulated — thanks to you.

Why is it so important to exaggerate the mood? Remember, your viewers weren't there; they didn't experience the subject with you. So while a few, subtle clues may be enough to rekindle your memories of the subject, your viewers need powerful, obvious signs in order to experience the same feelings you had. For instance, if your subject was hot, your painting has to look scorching in order for your viewers to get the message that it was hot. Humor your viewers — they need much more to spark their imagination.

Now, it's possible for a painting to be so expressive that the viewer is overwhelmed by the mood, but that's okay. I'd prefer to hear someone refer to my work as "too bold" rather than just "nice". And I'd rather have someone see one of my Chicago winter scenes and say, "It looks too cold", instead of, "It looks just like a photograph". At least I have the viewer feeling something, not just looking at things and thinking how "real" they are.

Here's the key to this whole concept: When choosing a mood or expression, keep it simple. Pick no more than two descriptions, such as warm and soft, to communicate. If you try to paint a warm soft light, casting bold dramatic patterns, across a colorful, yet delicate, table inside a textured rustic café, you'll cause "eye indigestion". That means you've gone to the buffet of artistic ideas a couple of times too often!

To help you stay focused on your one or two adjectives while you paint, I suggest you write them down and leave them on the table in front of you. Bring out only those photo references that express the same mood you're attempting to create. If you need to, look at other paintings that have the same mood so that it's very clear in your mind. Then keep reminding yourself that artists are paid for their vision, not their observations.

My preliminary sketch of the interior of Sacre Couer in Montmartre was all about value contrasts, shapes, edges and depth. But when I started the painting, I decided to focus on mood. As I laid down my first wash, I was thinking about two things — cool and soft. Only after I'd clearly established these feelings defined by my title — **"A Cool, Soft Silence" (22 x 30")** — did I refer to my sketch for information about the objects.

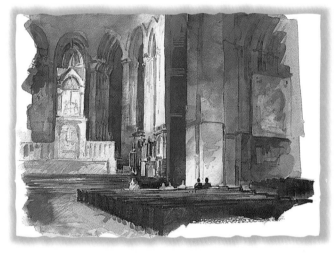

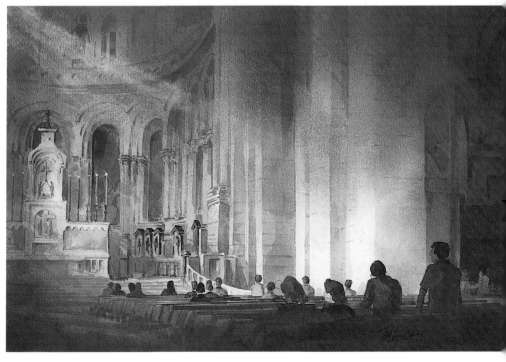

How to make Expression and Mood work for you

In these two demonstrations, you'll see how the very first wash is the key to the mood.

The most important thing for you to notice in these two demos is the first wash. The expression or mood in the first wash makes the painting, so it must be exaggerated. From then on, it's merely a matter of suggesting the fundamentals, which I've explained and demonstrated in the previous chapters.

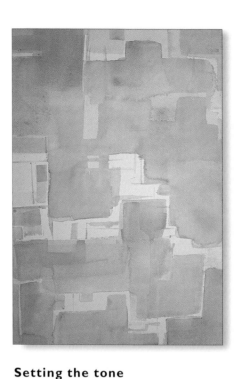

Setting the tone
To establish the bustling, animated mood of the painting right from the start, I began with an abstract pattern of rectangles and squares, using harmonious colors in light values.

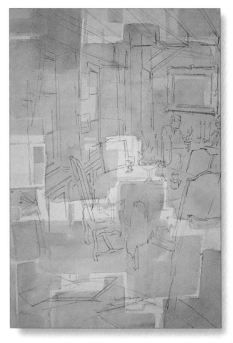

Mapping the shapes
After that dried, I decided which way to set the paper and drew out my café scene over the underpainting.

Demonstration 1
A busy, lighthearted mood

For this first demo, I decided to work out an unusual idea. I wanted to paint a café scene and capture its playful, active atmosphere by exaggerating it with a unifying pattern of rectangles.

Matting Tips

"If I do one thing in my life, it will be to reverse this terrible rule imposed by art groups: Light mats on all paintings. A mat is meant to strengthen a painting, not match the rest of the exhibit, so make sure it's the right value. When you want to bring out the light in a painting, use a dark mat. When you want to bring out the darks or fresh colors in a painting, use a light mat. If you have a warm impact area in a painting dominated by cool colors, use a cool mat and vice versa. I cringe when a client comes in with a decorator and the decorator says, 'See that pretty spot of red? We can bring out that color in the liner'. Don't emphasize one little spot in a painting! Use the mat to enhance the overall color scheme, either by continuing it or contrasting with the impact area."

Embellishing for impact

Starting at the area of emphasis, I began to build up the shapes using dark values of the same colors. Notice how I continued using the same shapes — even the cup, vase and flowers are rectangles — to accentuate the pattern theme.

Working the surface

Once I could clearly see how contrasting values would draw attention to my impact area, I developed the rest of the painting using less contrast.

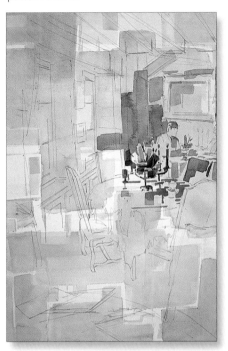

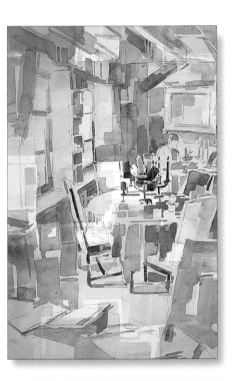

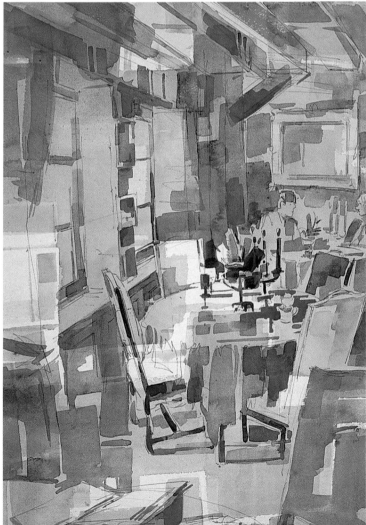

Exercising my creativity

I really had fun painting **"Café Shapes" (22 x 15")** because I challenged myself to grow by doing something unusual. I believe that "fun" experience really came across in the piece, giving it a happy, joyous feeling unified by the rectangular pattern.

93

Demonstration 2 — Dramatic lighting

In this painting, I wanted to capture the powerful drama of light-and-shadow patterns. Not wanting to create a warm, soft look, I went with a rich, dark, cool color scheme. To be honest, I spent more time drawing and carefully applying the liquid frisket than I did applying paint, but how long it takes to paint something isn't really important — it's all about how it ends up, not how you got there.

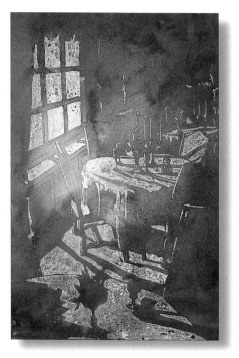

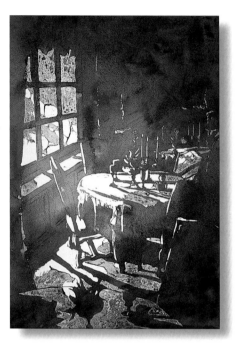

Starting with edges
To help exaggerate the mood, I wanted a hard edge, so I used liquid frisket over my drawing in the areas showing light, such as the window, table, floor and so on.

Staying focused
Over the dry frisket, I painted a rich, dark wash. I kept reminding myself that I was interested in only one thing — a bold pattern of light — so I restricted myself to cool colors and included only a slight suggestion of warm color at the light source.

Removing the frisket
Even as I removed the liquid frisket, I could see that I had successfully achieved my goals of laying down a bold pattern of light and shadow.

"Here's the key to this whole concept: When choosing a mood or expression, keep it simple. Pick no more than two descriptions, such as warm and soft, to communicate."

Exaggerating the mood

I then developed the impact area with a little more color, being careful not to overstate the impact area with layers and value changes. The figures in the background were nearly obscured, but the trade-off is that the mood/expression is exaggerated. Finally, I used a razorblade and an electric eraser to scrape and lift off some of the dark colors. **"Café Patterns" (22 x 15")** was finished.

What a difference in mood!

Compare this painting, **"Table for Two" (22 x 15")**, with "Café Patterns". As you can see, the subject is identical but what a difference there is in mood! Here, I was thinking about warmth and softness, not dramatic lighting as in the other painting. Notice how the fundamentals, such as value and impact area, are subtle so the expression can be felt sooner and more powerfully.

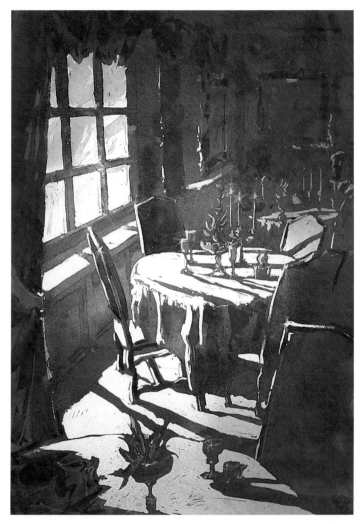

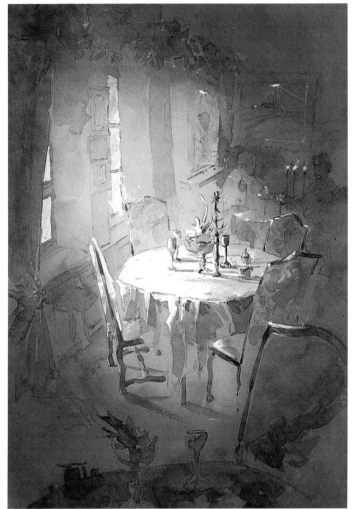

Workshop Experience

"A great way to put little touches of light in a painting is with an electric eraser loaded with an ink-erasing nib. With a little practice, you'll learn to gently lift off paint around candles, light sources and reflections so they appear to sparkle or glow."

On Location: Finding a Mood

Use these scenes to practice exaggerating mood.

Great references make for great paintings, especially if you make it a point to take pictures that capture different moods. For instance, look at the photos on this page and try to identify or describe the mood in each one. Now paint a quick sketch of one or more of these references, focusing on exaggerating the mood. Paint for about an hour, but spend no more than 15 minutes on each sketch. It doesn't matter if your subject isn't totally accurate or even recognizable, as long as the mood is very clear.

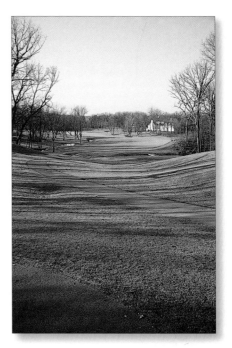

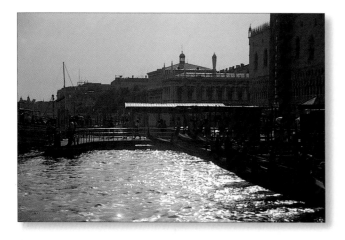

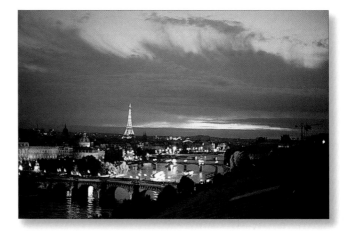

Workshop Experience

"Occasionally, when I'm trying to express something soft, I start out with a soft wash and block in the fundamentals, but then get carried away or too heavy-handed. To save the painting, I may re-paint the soft first wash as another layer, or I may take the trigger-spray bottle and spray off my heavy brushstrokes. Another option is to take the fine mist spray bottle and spray paint over the heavy areas to subdue them. Any of these methods will recapture the 'soft' feeling."

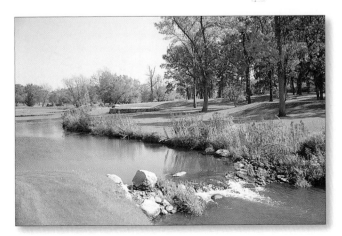

Using Expression as a Salvage Technique

You really have to go out of your way to inject mood into a work. Here's how it's done.

In these three examples, the artists obviously had certain moods and feelings in mind, but didn't exaggerate them enough for us to feel them. Look at how much more powerful the moods became when I revised each piece.

Nice rendition, shame about the blandness
This artist did a nice job of painting a door, bricks and baskets. But was there any mood or feeling here that would hold the viewers' attention?

It needed the drama of pattern and contrast to make it more entertaining. Now you care less about what you're looking at and more about how it feels.

"Sometimes, you may want the mood to be stronger and more important than the subject itself."

Disharmony of elements
The active feeling of these horses just didn't harmonize with the static shapes in the background.

By adding a curvilinear pattern of shadows, I've accentuated the feeling of movement in this painting.

Literal representation instead of drama
This original was about realism — a particular event, time and place.

Look at how much more dramatic it becomes when a mood is established through exaggerated lighting.

99

Showcasing Expression and Mood

I always exaggerate the feeling I want to express.

One of my painting mottoes is "Give the viewers their money's worth for their viewing pleasure". How do I do that? Fundamentals alone aren't enough. When I want to stir up emotion in my viewers' minds, I add a "ton" of mood for entertainment.

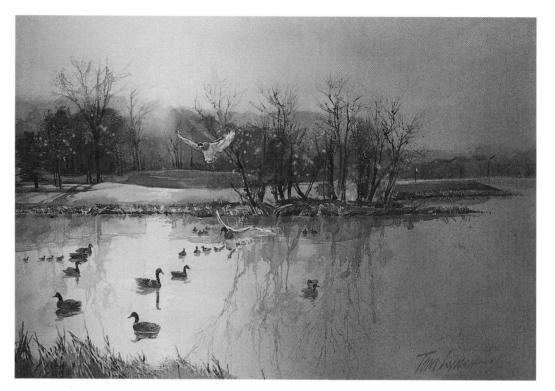

Let mood take center stage
"Start of the Season" (22 x 30") proves that peaceful and serene doesn't have to be boring. I used a whole slew of colors, shapes, edges and application techniques, yet kept them somewhat subdued to support the mood.

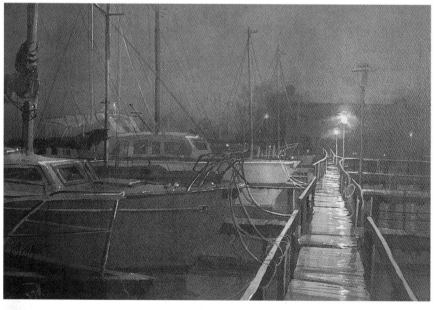

Mood can be soft and peaceful . . .
In **"Quiet Harbor" (14 x 21")**, the low-contrast values and subdued colors shroud this marina in a quiet, sleepy mist.

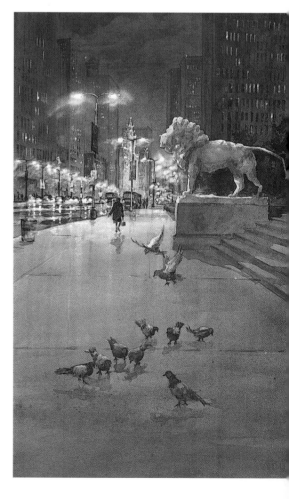

. . . or lively and energetic
Plenty of lights and small shapes put bustling energy in this cityscape entitled **"Proud City" (22 x 15")**.

100

Always include at least a touch of mood

"Kitchen Light" (16 x 12") is mostly about techniques, textures and value changes, but it still has a touch of a somber mood to it, too.

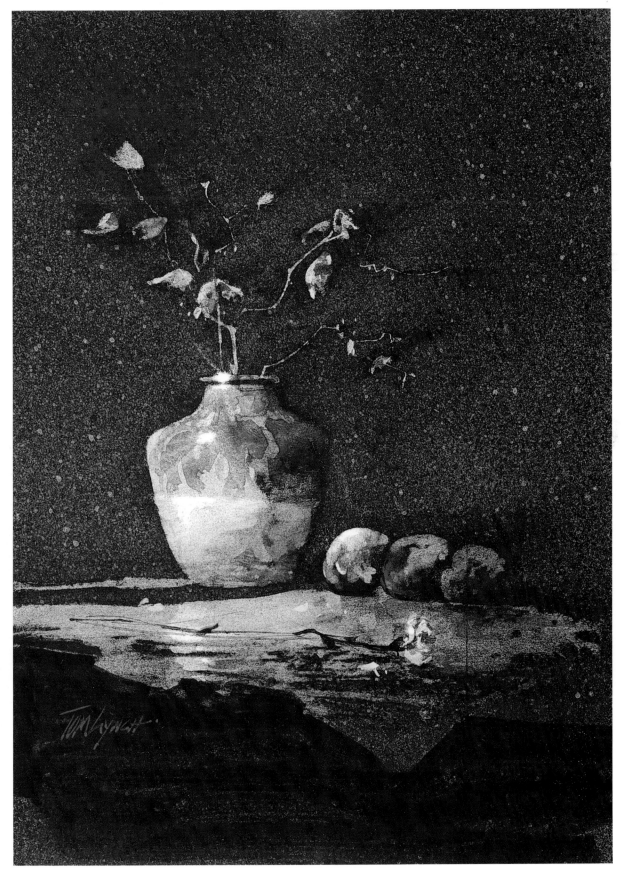

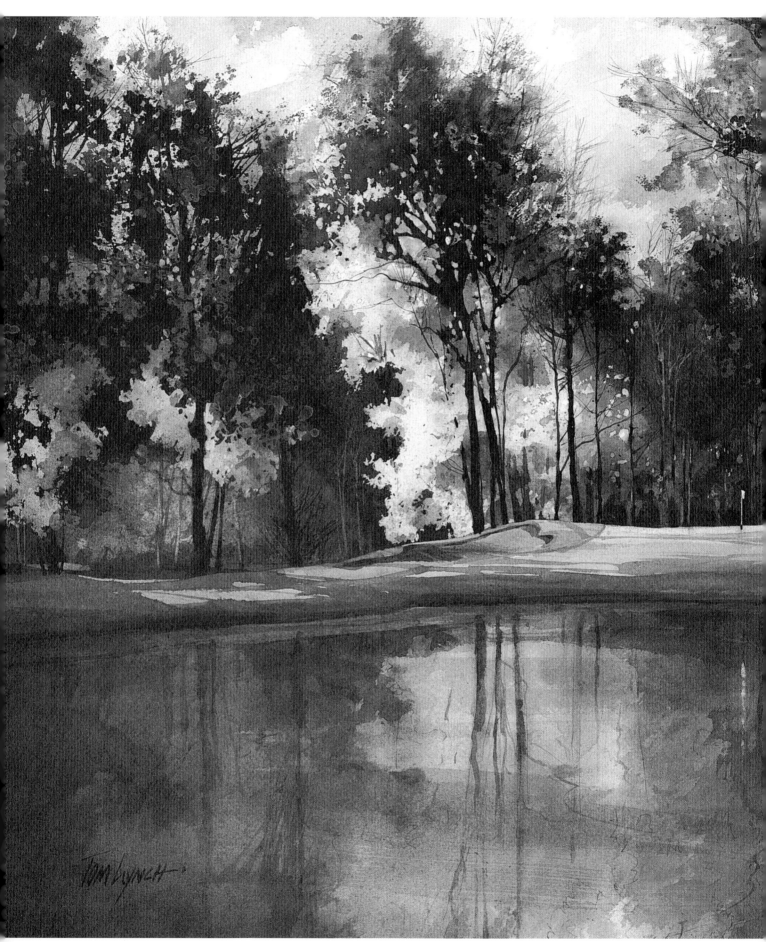

Demonstrations and Gallery Paintings

In the following demonstrations, you'll see how I organize my thoughts to form a plan of attack that involves all of the fundamentals I showed you in the first part of the book.

While my painting approach can be broken down into separate ideas, ultimately all of them combine to play a part in the overall success of my art. No matter what subject I choose, I take techniques, value, color, design, impact area and mood and consider how I can use them to achieve my goals for each particular painting.

"Quiet Time" (22 x 30")

Demonstration

This painting is all about contrast and value patterns.

I wanted to create a painting about mood, specifically, the feeling you get in the late afternoon in winter. Before getting started, I settled on the exact mood I was going for and expressed it in the form of a title — **"Sunlight Patterns"**. Right away, this told me I was going to be using a lot of contrast, both in temperatures to accentuate the sunlight and in values to establish patterns.

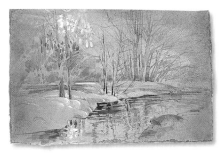

Since mood was intended to dominate this painting, the exact details of the subject and the other fundamentals became less important. Unique to this scene, I built in two possible impact areas, one in the upper left zone and one in the lower right zone (see the design grid in Chapter Five: Impact Area). Later, I would go with whichever one appeared to be stronger as the painting developed. Either way, I wanted the sunlight to catch the attention and lead your eye with the patterns created by that light.

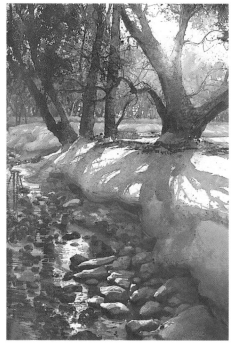

Gathering resources

For inspiration, I combined a preliminary on-site sketch with this photo reference to create a design. I changed the composition somewhat to accommodate a better horizontal format and form a more interesting design of shapes. I also pulled out two older works — **"Winter Morning"** and **"Snow Shadows"** — to help me visually re-capture the feeling I was going for.

Saving the light

I began by lightly drawing my subject on 300lb cold press paper. On an overlay sheet of wet-media acetate (see page 67), I used black paint to plan where I was going to preserve the whites with liquid frisket.

Then, following this "pattern", I painted liquid frisket on my watercolor paper in the area where the sun was going to come through the trees, as well as some spots where light would fall on the snow-covered ground.

Setting the mood

The first wash was critical as it established the warm glow of light against the cold winter snow. I used a progression of warms to cools: Permanent Yellow Lemon, Permanent Orange, Permanent Red, Permanent Magenta, Cerulean Blue, Cobalt Blue, Ultramarine Blue and finally Royal Blue. Occasionally, I accented this progression with Peacock Blue and Hookers Green. As I painted, I kept reminding myself, "Light to dark, warm to cool, interesting brushstroke shapes and numerous color changes".

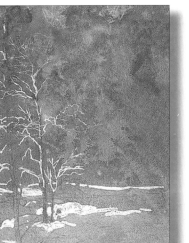

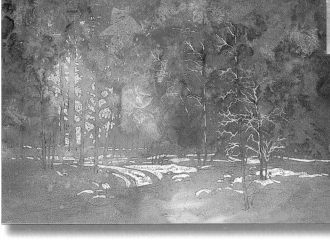

Mixing in texture

Before this first wash dried, I took advantage of this opportunity to add texture. Using a pump-spray bottle, I sprayed on a few tiny dots of water to create a mottled texture. In some areas I also blotted the water with a tissue to yield other textures.

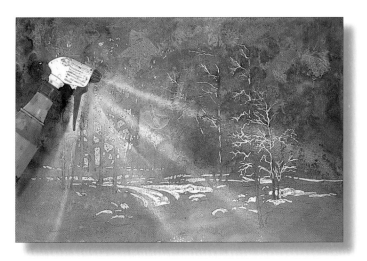

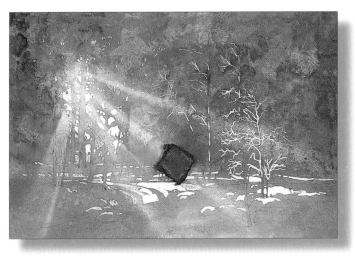

Bringing in sunlight

After the first wash dried, I used my trigger-spray bottle to create rays of light. Holding the bottle at an angle, close to the paper, I used the wide spray setting to lift off the paint in directional "rays". Notice that there are different angles and different amounts of paint sprayed off to give the rays variety. I quickly blotted up the excess water with a cloth towel, and let the paper dry thoroughly before continuing.

Revealing the patterns

After the paper had dried again, I slowly removed the liquid frisket with a rubber cement pick-up. I lifted off small amounts at a time so that I could get some idea of how much white paper to leave and how much to cover with later glazes of paint.

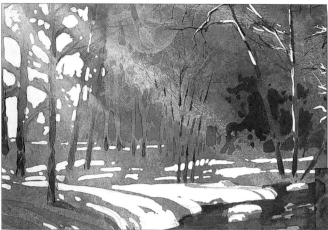

Going for impact

After I'd removed all of the rubber cement, I picked the area of emphasis in the lower right zone and began to enhance it. Super-darks (see Chapter Three: Color) created extreme value contrasts there to grab the attention. I also began to build up a layer of trees, painting some dark values in front of lights and others behind lights to create subtle positive and negative tree shapes. In the river, I used a gradation of color, making it dark in the distance to keep the focus on the impact area and letting it get lighter as it moved closer to the foreground.

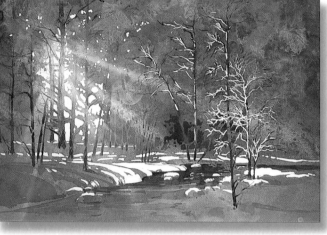

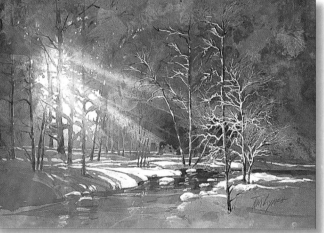

Returning to patterns

Again, to exaggerate the pattern of light, I deepened the color of the shadows between the rays of sunlight. I used a straight-edged piece of paper as a shield, and sprayed a light mist of Cobalt Blue, paralleling the rays of light. These "rays of shadow" enhance the mood and direct you to the impact area.

"Artists are paid for their vision, not their observations."

Workshop Experience

"Texture is a great way to get and keep your viewer's attention. Texture means there's something new happening every couple of inches, encouraging your viewer to explore your work more carefully. In fact, a variety of textural marks can be the primary purpose behind a painting powerful enough to entertain a viewer."

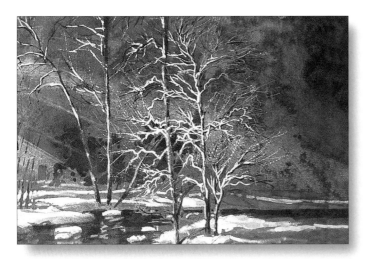

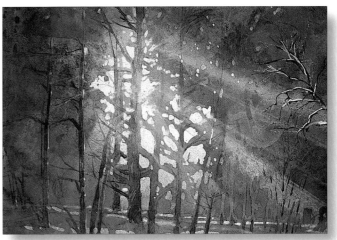

Enhancing the mood

Before making any refinements to **"Sunlight Patterns" (15 x 22")**, I re-focused on my intended mood — a touch of warmth and the patterns of light. On the trees near the impact area, I took a razorblade and scraped the paper to bring out the small frozen branches being hit by light. Finally, I used an electric eraser to soften the edges left by the liquid frisket and to enhance the effect of light coming through the trees.

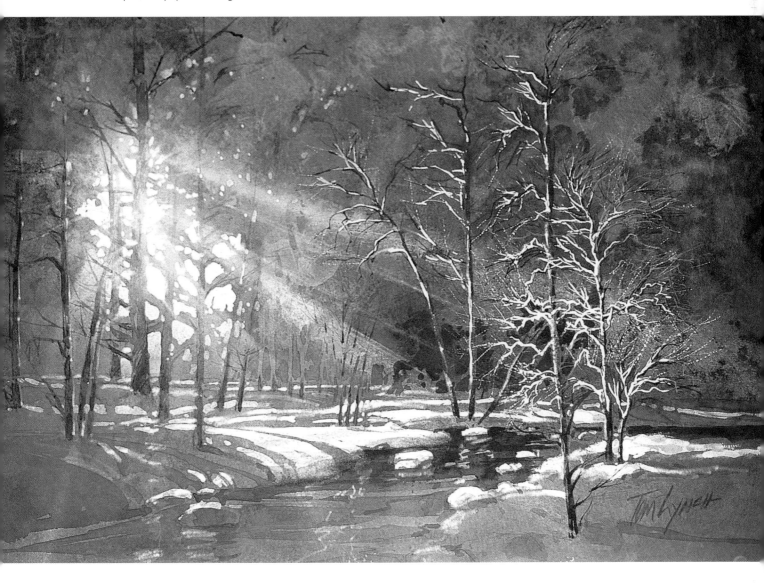

Gallery

"Venice Glow" (15 x 22")

"Venice Sunset" (22 x 15")

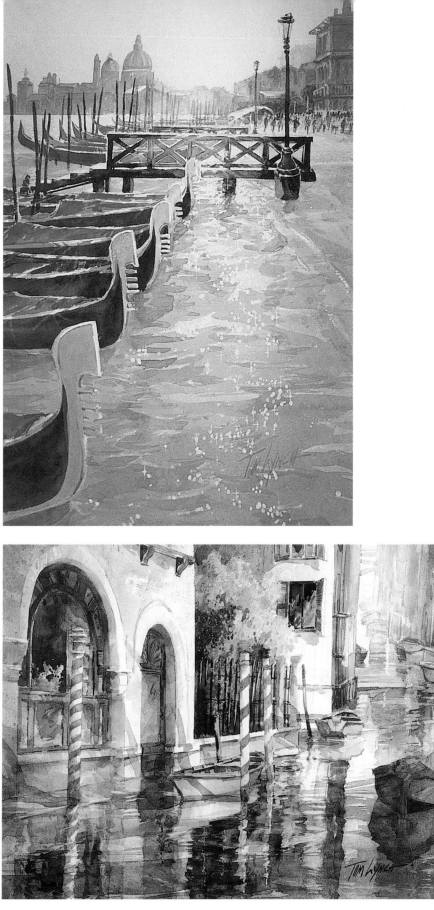

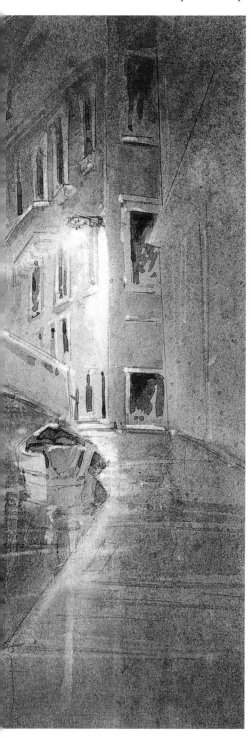

"Venice Stripes" (15 x 22")

Demonstration

How I used unusual lighting and dramatic mood to salvage a potential disaster.

I had intended to paint this flower shop in a warm, sunny setting, using the table full of potted plants and flowers as my impact area. As you can see, things didn't turn out quite the way they were planned. It just goes to show that even the most seasoned professional can miss the mark occasionally. The difference for me, though, is that I refused to give in and let the paper win. I kept working at it until I'd created something I'm proud of, thanks to its unusual lighting and dramatic mood. As I often say in my workshops, "If all else fails, make it into a night scene".

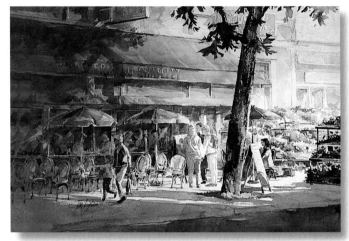

Formulating the idea

I liked the building in my original reference photo, but I felt the design would be stronger if I flipped it around so that the house was on the right, while the table — my area of emphasis — remained where it was. Knowing I wanted to paint this scene in a warm light, I brought out an older painting called **"Café Shadows"** for inspiration. Based on these two references, I painted a color sketch.

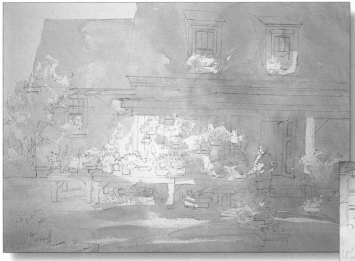

Establishing the mood

After drawing my design on my paper, I covered it with my first colorful wash. Working left to right, I went from warm and light to cool and somewhat darker. I used Permanent Yellow Lemon, Permanent Orange and Permanent Red for about two-thirds of the wash, then moved into cooler hues of Cobalt Blue. I left plenty of white paper in what was to become the impact area.

Looking for emphasis

Since the impact area is integral to the success of this painting, I focused on it first. I did some negative painting in a rich, dark mixture to create a deep shadow, and added bright colors to the flowers and baskets nearby. From this point on, my goal was to maintain the bright color, high contrast, sharp edges and intricate detail found here by painting everything else in a more subdued manner.

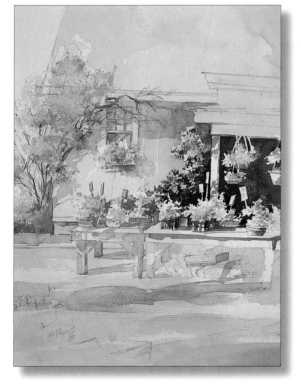

Working around the painting

Next, I turned my attention to creating depth through value changes. Using slightly darker versions of the same colors as the first wash, I started developing the background. Under the table, I gave the impression of general clutter by combining and abstracting shapes, as shown in Chapter Five: Shapes. I concentrated on making interesting marks with my brush, but made sure these areas remained subtle so as not to detract from the impact area.

Workshop Experience

"People always ask me, 'How do you know when to stop?' My answer is twofold. First, you need to know what you're trying to say, meaning what mood you're intending to convey. Second, you need to check your fundamentals by putting a mat around your work-in-progress. Is there an impact area? Does it have depth and/or pattern because of changing values? Is the color expressive and bright? Are the shapes interesting? If you've used your fundamental concepts to express what you wanted to say in a clear, concise way, you're done. It's not about creating a painting that looks just like a photograph. Remember, the best compliment you can hear is, 'That is simply elegant'."

Developing other areas

Moving to other parts of the painting, I blocked in the shadows on the window dormers. While that was drying, I introduced color to the leaves and flowers in the window box. To link the foreground to the middle ground, I introduced shrubs and a shadow that graduates from light to dark, warm to cool. Returning to the area under the table, I created a lost-and-found shadow pattern. I made sure everything I did had a variety of values, colors and shapes, but never so much that the viewer would be distracted.

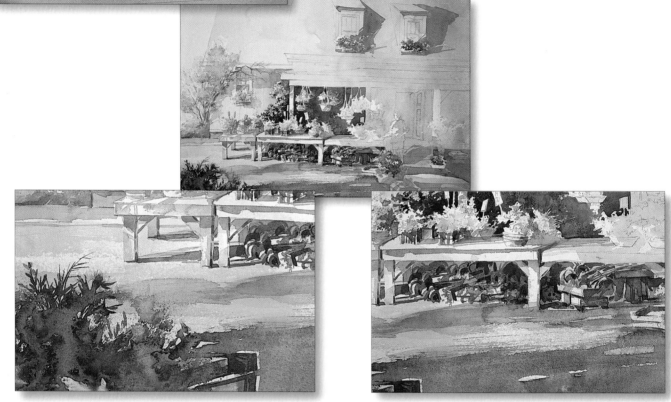

Workshop Experience

"People tend to admire detail and the ability to paint detail. But to my way of thinking, putting in a lot of detail is just making a picture. If you want to make art, you have to mix creativity in with your technical expertise. Fortunately, there are plenty of ways to be more creative when you're painting — exaggerate the light source, dramatize the patterns, intensify the shadows, brighten the colors, vary the shapes, loosen up the brushstrokes, add more texture and above all, put more variety in everything you do. The less 'real' or detailed you allow yourself to be, the more you'll be able to capture the impression or essence of your subject, which is what creating a painting is all about."

Stopping for evaluation

After further additions to the porch, roof, sky and background, I felt dissatisfied with the painting. I decided to opt for drastic measures and turn it into a night scene with a path of artificial light. Out came the darks in my palette — Royal Blue, Ultramarine Blue Deep, Cobalt Blue, Permanent Red and Cerulean Blue.

Turning day into night

Starting with darks at the top, I painted a graded wash over the entire scene and used my misting spray bottle filled with Cobalt Blue to soften the contrast along the four sides. Despite the dramatic change in mood, I preserved my initial impact area by retaining its bright colors, extreme value contrasts, crisp edges and details.

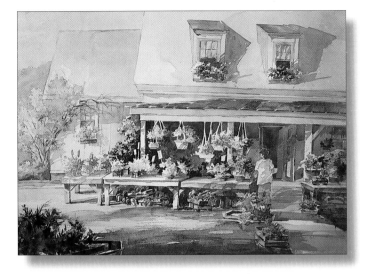

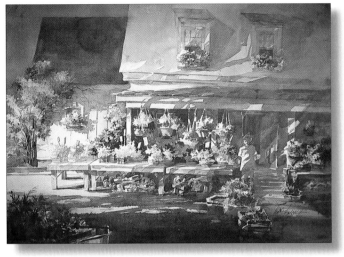

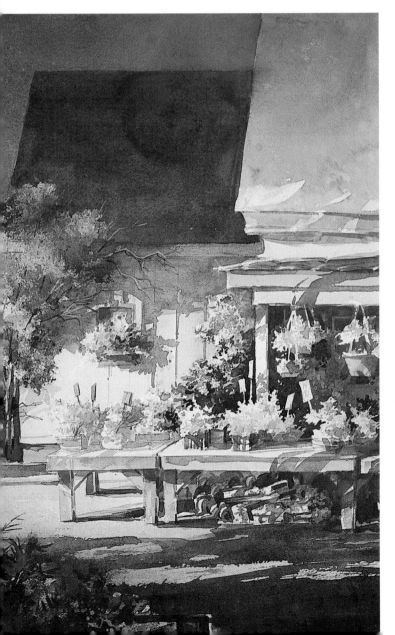

Cropping for impact

I still felt the painting needed impact, so I did some creative matting and found a vertical section that restored that feeling of warm light. Remember, many great small paintings were once larger. I cut the painting in half and called it **"Cut Flowers" (22 x 15")**.

> **"I decided to opt for drastic measures and cropped for impact."**

Gallery

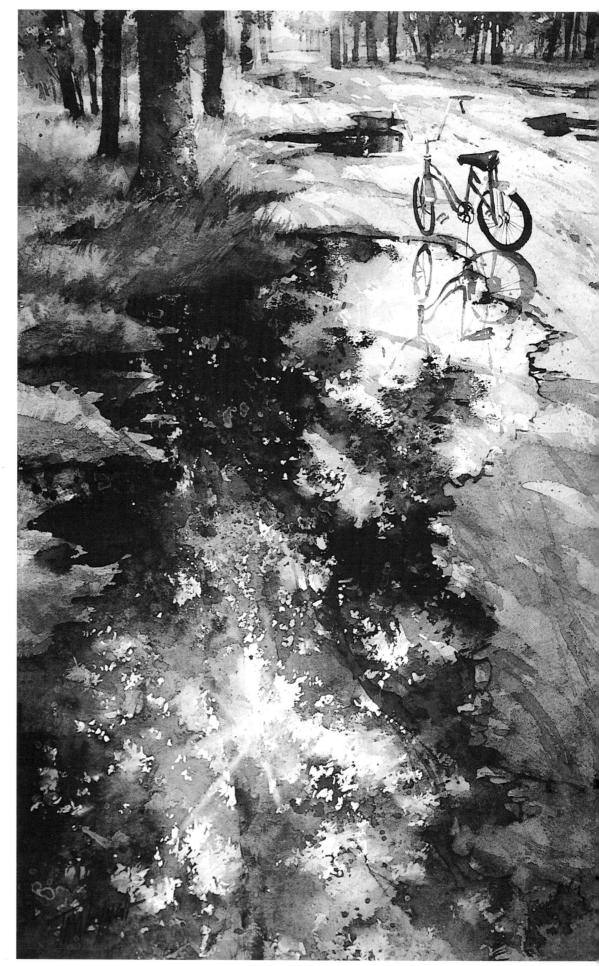

"Scott's Bike"
(22 x 15")

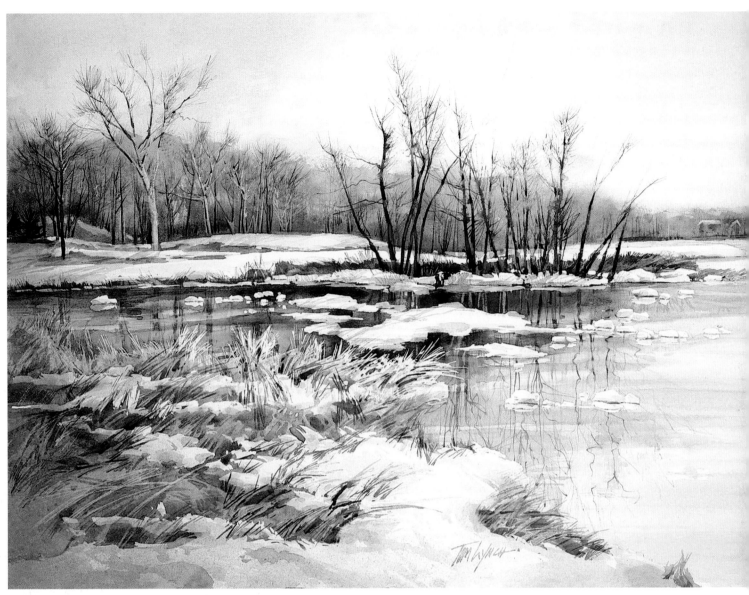

"Hazeltine" (22 x 30")

"Wynstone" (22 x 30")

115

Demonstration

How I made an interesting painting without overpowering the impact area.

This painting is about mood — a quiet moment of reflection and gratitude. My hope is that it will encourage all who see it to pause for a moment of thanksgiving.

Getting ready
I shot the two photographic references at the same time, one with a flash and one without. I often do this so that I can get a feeling for what the objects look like at different times of day and in different moods. I also referred to an on-site sketch and an earlier painting called **"Cathedral Light"** for ideas about a soft, quiet mood.

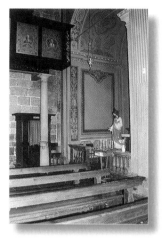

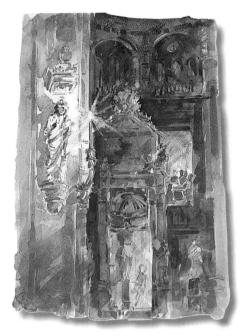

Preserving the light
Just by looking at my pencil sketch, I could see the finished painting clearly in my imagination. With this good feeling about where I wanted to go, I could skip any kind of preliminary sketch and draw the image on my watercolor paper. Then I used liquid frisket to preserve the candle flames, the window and parts of the statue and figure.

Adding interest

After this initial wash dried, I used the trigger-spray bottle to lift off rays of light. This adds a soft touch of variety to the background that won't detract from the impact area.

Considering my options

Before applying my first wash to the background, I debated long and hard about how to make this large expanse interesting without letting it overpower the impact area below. I considered adding a more complex design of archways or putting in a painting or tapestry wall-hanging, but I opted for a pattern of filtered light and shadow to keep the image and message simple. I mixed up a large batch of a colorful gray made up of Yellow Ochre, Permanent Red, Cerulean Blue and Royal Blue, plus a small amount of Cobalt Blue, and laid in the wash, allowing it to become lighter toward the window.

Workshop Experience

"When you work with shadows, keep them very wet. The longer your dark paint stays wet, the more chances you'll have to alter the shapes and soften the edges. This is important, since dark shadows get noticed and their edges need to be blended just right."

Going too bright

For the dark wash covering the lower two-thirds of the painting, I used Cobalt Blue, Ultramarine Blue Deep, Royal Blue, Permanent Magenta and Burnt Sienna. But after this wash dried, a rare thing happened. I decided the colors were too bright and clear, which didn't fit with the old, weathered stone interior of the church. To tone down the intense purples, I sprayed a light mist of Yellow Ochre, followed by a light mist of Cerulean Blue.

Bringing out the glow

Next, I introduced shadows, shapes and architectural detail to the wall in both the sunlit and shadowed areas. I then sprayed off color around the candles to create a soft glow. I used a towel to thoroughly blot up the water after each spray to stop the rays from merging into one.

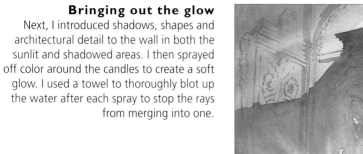

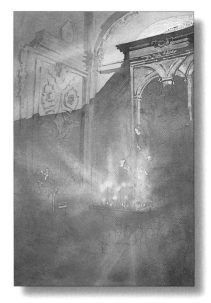

Above Right: Painting sparkle

Taking a cue from the actual gold leafing in the cathedral, I applied several coats of gold metallic watercolor paint to create architectural details. The effect was spectacular, especially over the dark wash. (I wish you could see this under a picture light!)

Contouring the shapes

My next step was to start shaping and shading parts of the painting. In the statue, I used stronger variations of the colors in the first wash, allowing the colors to be warmer and the edges to be softer near the glowing candles, and making the colors cooler and the edges harder as I moved higher up the statue. I used mainly cool colors and subtle shapes in the secondary figure near the railing. Dark values in the painting behind the statue helped strengthen the contrast in the impact area.

Above Right: Building subtle details

To create the railing, I painted in some darker values of blues and lightened other areas by re-wetting the first wash and blotting the color up with a towel.

Checking my progress

Finally, I removed the frisket from the figures, candle flames and window. I let the painting sit for a few hours before considering what refinements were needed. During that time, I studied the painting under both a dark mat and a light one, and soon realized that the painting had moved in a different direction than I'd originally intended. While I'd taken many steps to create a dominance of soft edges, there were also a number of hard edges. Now I had to make a choice between "going with the flow" and reinforcing the hard-edged look, or toning things down to return to my original "soft" concept.

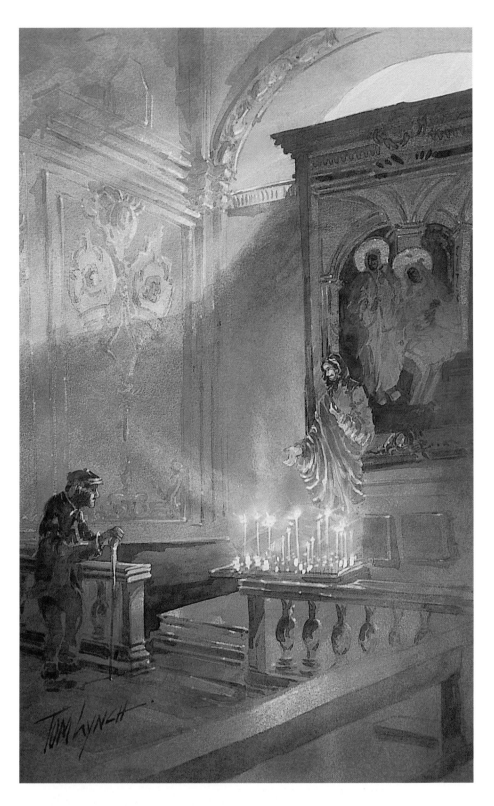

Refining the mood

I decided to go for a softer look by softening the sharp line of the shadow, adding a few more curved lines to the architectural detail on the far wall and filling in some of the bright whites in the figure and on the statue with light values. Last, I lifted a little color from the painting behind the statue to soften those edges. These refinements brought out the softness as well as the glowing light around the impact area in **"Spiritual Time" (22 x 15")**.

Workshop Experience

"Stop every couple of inches when you're painting and check your edges. If you don't have variety in the edge you've just put down, do something to alter it. Use your brush, a sponge, a tissue or a few dots of water — anything that will bring a change to some part of that edge."

Gallery

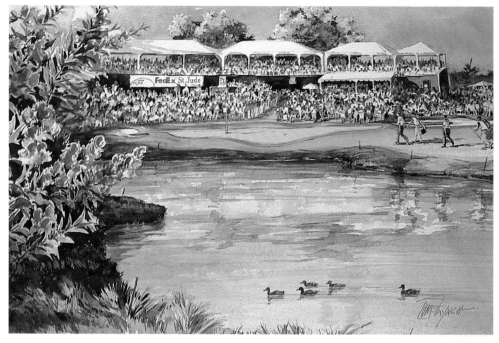

"Royal Melbourne" (22 x 30")

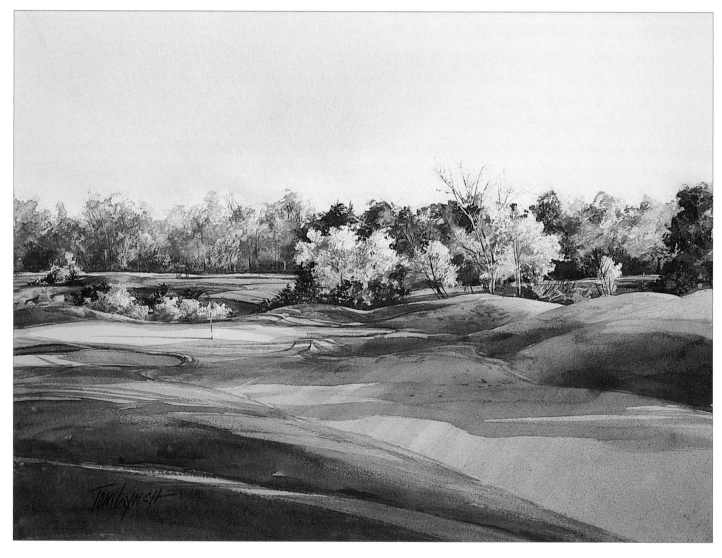

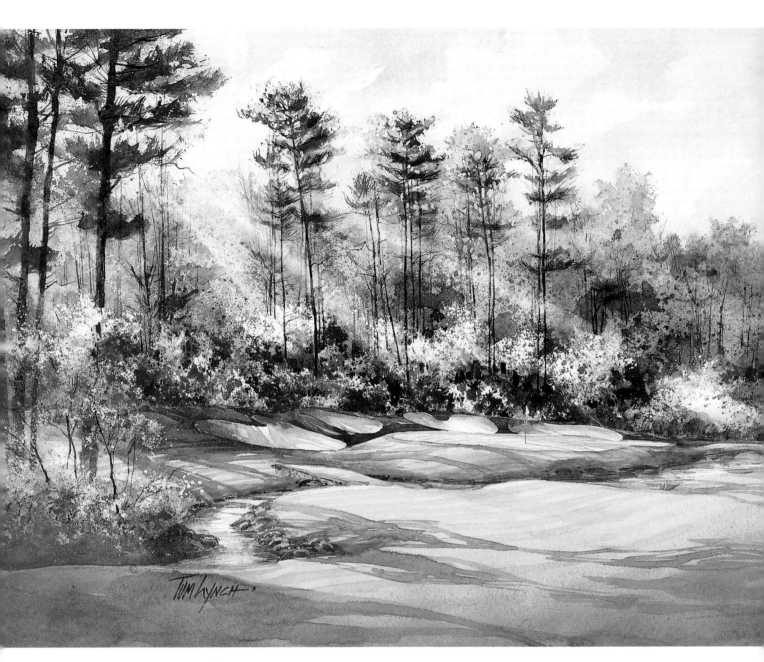

"13th at Augusta" (22 x 30")

"I keep saying it — decide on a mood, and keep reminding yourself what it is."

Demonstration

Here I had to be careful not to overdo things and lose the soft touch.

As I've said before, I rarely rely on just one photo or sketch when designing a new painting. I'll pull parts from as many references as I need, not only for shapes but also for ideas about mood. In this case, I was going for a soft touch or mood.

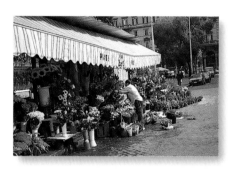

Combining ideas

To design this composition, I pulled together pieces of seven different photos. The Eiffel Tower, the flower close-ups, the flowers at a distance, the figures, the umbrellas and the details of the market stalls all came from separate references. These were shot at various locations under different lighting and weather conditions, but that doesn't matter since I was looking for shapes, not color references.

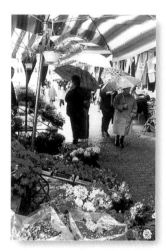
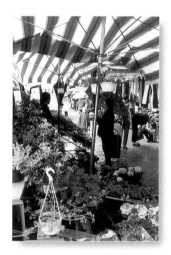

Starting with impact

I started with the impact area. Because I'd already decided on a soft touch, like that in "A Soft Touch" on page 90, I knew the area of emphasis would need slightly brighter colors, darker values and sharper edges to hold the eye. I had to be careful not to overdo things or I'd lose the soft touch, which is why I chose to work on a hot press paper. I knew the hot press finish would allow me to lose edges between layers, enhancing the soft look.

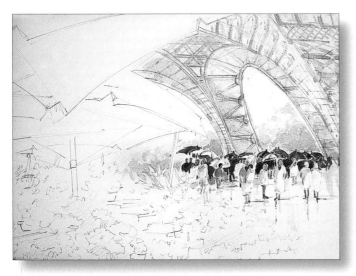

Details: Creating a softer look

I then painted the background, stylizing the tower shapes and layering the figures. I painted the figures darker than necessary, then turned right around and lightened them by using a trigger bottle to spray off some of the color. I used this technique because it creates a more mottled, softer look, as if on a rainy day. I did leave a few darker accents, but notice that they're closer to the impact area.

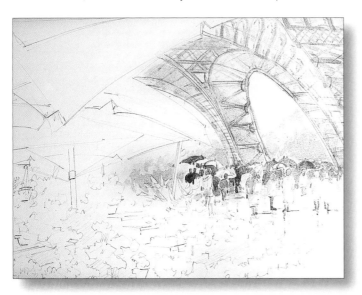

Workshop Experience

"I think there's nothing more boring than a painting of a well-known landmark, especially when it's placed right in the impact area. But that doesn't mean I avoid painting famous, prominent places. Instead, I like to employ a technique I call 'the art of misdirection'. Rather than play up the obvious, I try to subdue that famous, immediately recognizable thing and emphasize some other, less likely area. This has a tendency to surprise viewers when they finally 'find' the familiar landmark hidden in the painting, which encourages them to form an attachment to the work. Because they've been fooled by this entertaining visual game, they want to see if others are, too. Sometimes it takes as long as a year for a collector to discover the landmark, but in every case, the person has come back to say, 'I like my painting even better now'."

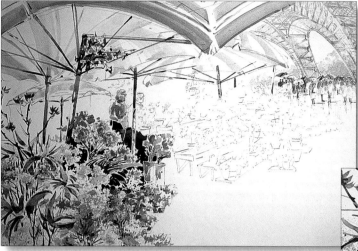

Stylizing shapes

Next, I put in the large striped umbrellas in the foreground. To disguise the fact that they have sweeping curves similar to the design of the arch under the tower, I stylized these shapes and varied their sizes and colors. I continued building up the foreground flowers as well, giving them a variety of shapes and colors, but never as much contrast or detail as the impact area.

Detail

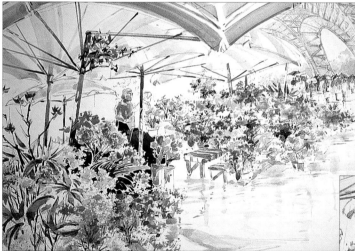

Details: Supporting the theme

As I laid in the middle ground flowers, I constantly compared them to the impact area, foreground and background. I wanted this area to harmonize with the rest of the painting while offering a breath of fresh air due to the variety of colors, sizes, shapes and values.

124

Pulling things together

It was time to address the horizontal planes. I put in the ground, adding a nice gradation of color and wet-looking reflections. In the small patch of sky, I decided to add some more darks, especially behind the figure. This enhanced the impact area, helping to tie it in with the rest of the painting.

Softening for effect

As always, I checked to see how I might reinforce my "soft" theme. I decided to lift out more color in the umbrellas and to modify the value contrasts in the middle ground. Showing more white paper also simplified this area, bringing out more of the impressionistic feeling I wanted in **"Flowers Under the Tower" (15 x 22")**.

Workshop Experience

"It's so important for every artist to strive for variety in his or her work! Anyone who sees a collection of my paintings knows I favor bold colors and contrast, but that's not all I do. Occasionally, I challenge myself with a change of pace — perhaps I'll try working with pale colors or an unusual subject. You, too, can expand your horizons by exploring the many possible ways of communicating your vision".

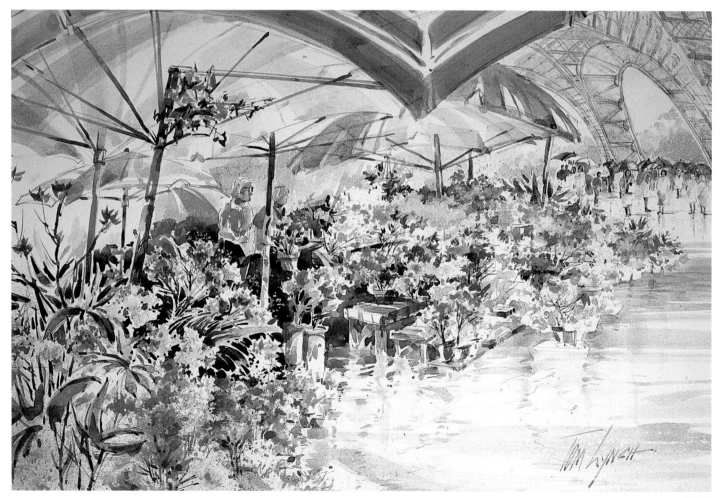

Gallery

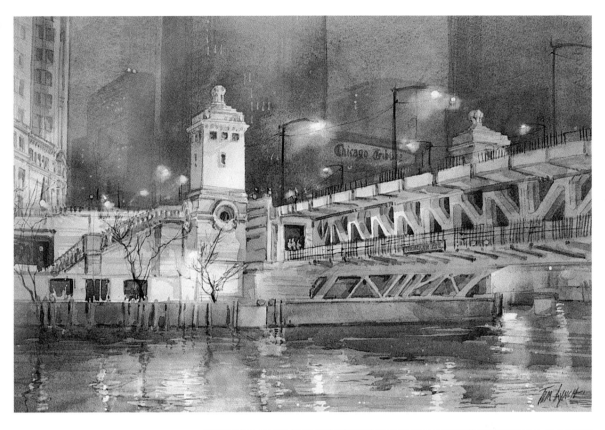

"Michigan Avenue Bridge" (15 x 22")

"I refuse to give in. I keep at it until I create something I'm proud of."

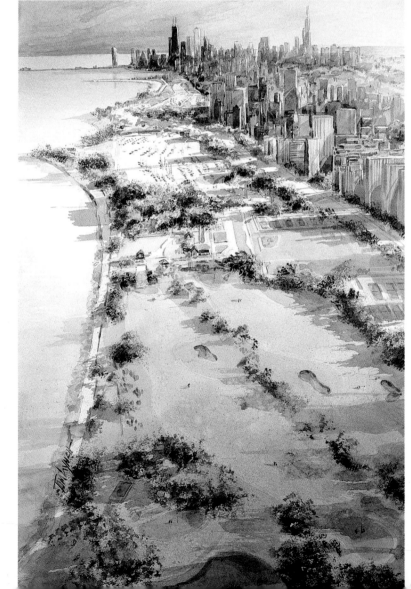

"Leisure Time" (22 x 15")